PAINTINGS

IN THE NATIONAL GALLERY OF SCOTLAND

Published by the Trustees of the National Galleries of Scotland

The Building

It was designed by William Henry Playfair (1790-1857), and built between 1850 and 1857. It is one of the finest classical buildings in Edinburgh. It was shared with the Royal Scottish Academy until 1910 when the Academy moved to the Royal Institution building in front of the National Gallery, on Princes Street. This was also designed by Playfair and it is here that the RSA's annual exhibitions are still held. The New Wing of the National Gallery, constructed below ground level, on the east side, was opened in 1978.

The Collection

It developed from a nucleus of pictures owned by the Royal Institution. The most important of these were the 38 paintings bought for the Institution in Genoa and Florence in 1830/31 (they included Van Dyck's *Lomellini Family*). These together with others owned by the Royal Scottish Academy were put on view in the new Gallery in 1859. Because, at first, there was no purchase grant, expansion of the collection depended on gifts and bequests (most notably, in the earlier years, Lady Murray of Henderland's of 18th-century French pictures). Important contemporary Scottish pictures were bought for the Gallery by the Royal Association for the Promotion of the Fine Arts in Scotland. The first payment of a regular purchase grant of £1,000 was made in 1910, to be supplemented in 1919 by the interest on the money left to the Gallery by James Cowan Smith. The Gallery continues to add to its collection and in recent years has received valuable support from the National Art-Collections Fund and the National Heritage Memorial Fund.

Scope and Arrangement of the Collection

It encompasses European painting from the 14th century to about 1900. Artists who were active after this date are represented at the Gallery of Modern Art.

The arrangement is roughly chronological, with the earliest pictures hung in Room 7 (see the plan at the back) and the latest in Room 23. The Scottish pictures, with certain exceptions, may be seen in the New Wing. The majority of paintings described here are regularly on show. Other paintings that are either less important or of more specialised interest, are hung in the Study Collection (Room 14).

Prints, Drawings and Watercolours

The collection of European graphic art from the 15th century to the end of the 19th century is housed in the Print Room. Since there are over 15,000 items in the collection only a small proportion can ever be displayed in the regular exhibitions that are held in the New Wing.

There is a wide range of European prints, from Mantegna to Manet with fine collections of Dürer, Rembrandt and Goya. The collection of drawings and watercolours is also extensive. A published catalogue describes the impressive collection of Italian drawings, but the collection of Netherlandish and a smaller group of French and German drawings also contain outstanding sheets. The Vaughan Bequest of Turner watercolours, always on exhibition in January, is visible by appointment in the Print Room at other times, and is the highlight of the distinguished collection of English watercolours. The Gallery's holding of Scottish drawings is unrivalled.

The Duke of Sutherland Loan

Since 1946 a group of pictures has been lent to the Gallery by the Duke of Sutherland whose collection is among the finest still in private hands. It includes Titians, Rembrandts, the Bridgewater Raphaels and the Poussin 'Sacraments'. The main part of the collection consisted of the French and Italian pictures from the Orléans Collection which were brought to London for sale in 1797. They were bought by a syndicate of three men of whom the 3rd Duke of Bridgewater was one. At his death in 1803 the latter bequeathed most of his pictures and Bridgewater House, where the majority of them hung, to Earl Gower who became Marquess of Stafford and later Duke of Sutherland. His second son, Lord Francis Egerton, who became Earl of Ellesmere in 1846 inherited most of the collection including the Bridgewater pictures. They passed by descent to the 5th Earl, the present Duke of Sutherland.

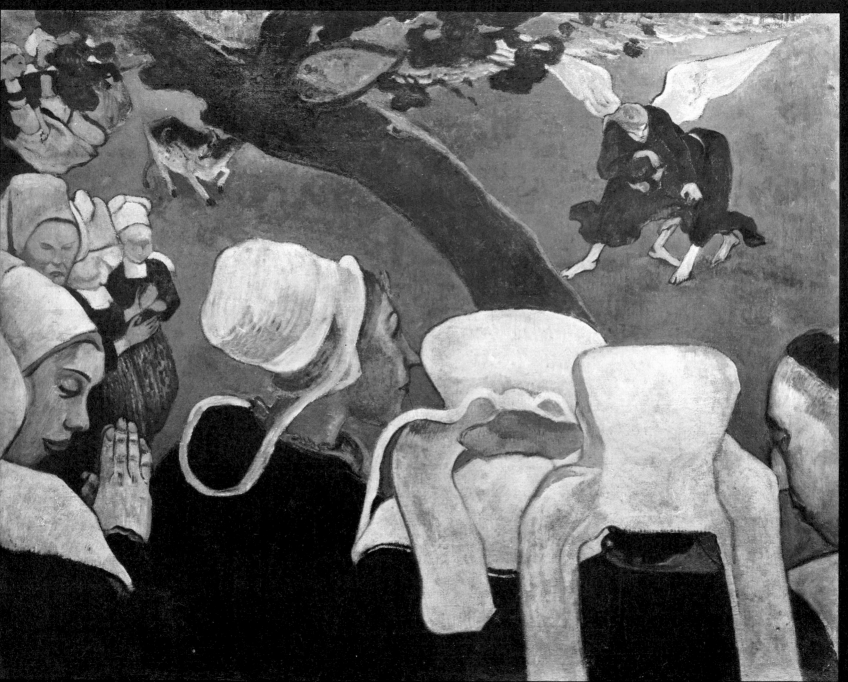

Gauguin: The Vision of the Sermon

AVERCAMP

Hendrick Avercamp (1585-1634) was trained in Amsterdam. By 1613 he had settled in Kampen. He belongs to the first generation of realist landscape painters in Holland, who began with vivacious, colourful scenes in which the figures are a predominant interest, and slowly developed a sense of distance and atmosphere from their own observation. Avercamp specialised in skating scenes, at first very clearly influenced by the winter pictures of Pieter Bruegel.

Winter Landscape

It shows the walls of Kampen in the middle distance, and was perhaps painted about 1630.

BACCHIACCA

Francesco Ubertini (1495-1557), known as Bacchiacca, was thirteen years younger than Raphael, a friend of Andrea del Sarto (q.v.) and among the first of the 'mannerist' painters in Florence.

Moses striking the Rock

The thirsty Israelites are shown complaining to Moses in a little scene on the rock, and in elegant assembly with all their livestock in the main scene below. The picture is presumably connected with scenes of Moses painted by Bacchiacca in 1525 for the Compagnia dell' Orciuolo, apparently a fraternity of jug-makers or jug-vendors in Florence. This explains the rich variety of elaborate but quite inappropriate jugs and vases from which the Israelites are drinking.

BASSANO

Jacopo da Ponte (1510-1592/3) was the leading member of the family of painters who take their name, Bassano, from the town on the Brenta to the north-west of Venice where they worked. He studied in Venice under Bonifazio from 1530 to 1535. His mature work was influenced by Titian.

The Adoration of the Kings *opposite 1*

It was painted fairly early in his career, probably in the early 1540s. Nothing precise is known of the circumstances in which it was painted, but the atmosphere it creates suggests a part of them. In a strange setting, each part of which is credible while the whole of it is improbable, we see a bustling throng of Italian men and boys of the 16th century. Many of them go about their business oblivious of the Holy Family, which they seem to have crowded to one side of the canvas. Two of the Kings, and at least the two boys behind them, look like portraits, no doubt of the family that commissioned the altarpiece. That they should be represented in worship was a custom that had by this time lost much of its former seriousness. Bassano interprets the whole scene with a richness and splendour of colour that has the resonance of a brass band.

Portrait of a Gentleman

This was painted in the later 1560s, when the mood of Venetian painting had changed (see note on Titian's *Diana and Actaeon,* page 30). The ambiguous sense of space in this portrait, and the unassertive treatment of head and ruff, are in striking contrast with the ebullient self-confidence of the two *Portraits* here by Andrea del Sarto and Quentin Massys.

BATONI

Pompeo Batoni (1708-1787) was born in Lucca. At 19 he went to Rome where he lived for the rest of his life. Early in his career he painted altarpieces and devotional pictures and scenes from classical history and mythology. He is best remembered however for his portraits which brought him both fame and wealth in his lifetime.

The Sacrifice of Iphigenia *opposite 2*

This is among Batoni's finest history pictures and dates from about 1740. It is seen to brilliant effect in its magnificent French frame which is contemporary with it. Iphigenia was the daughter of Agamemnon who had offended Diana by killing her favourite stag. To appease the goddess and to ensure the success of the Greeks here assembled at Aulis before setting out on the Trojan War, Iphigenia was offered in sacrifice. As the fatal blow was about to be struck she disappeared and a beautiful stag took her place. This fine classical composition perfectly demonstrates the refinement of Batoni's technique and his supremacy as a draughtsman.
(Earl of Wemyss and March loan.)

Portrait of Princess Giustiniani

It was painted when the artist was 77 and shows a depth of psychological penetration rare in Batoni. The sitter was an Irishwoman, Cecilia Mahony. Her blue sash and ribbons and her beautifully painted hands are delightful foils which soften the effect of her somewhat forbidding expression. Batoni's portrait of her husband is now in a private collection in Rome.

BONINGTON

R.P. Bonington (1802-1828) was born in Nottingham, but was taken by his parents to live in France in 1817/8, where he spent most of his short life until he died of consumption. He began by painting landscapes in water-colour, learning from a member of Girtin's circle. In Paris he formed a friendship with Delacroix (q.v.), with whom he had much in common.

Grand Canal, Venice; and Landscape with a White House

Bonington's pictures, most of them very small, are mainly of the French coast, Venice and Genoa, and romantic pictures of imaginary or historical scenes. His first visit to Venice was in 1826.

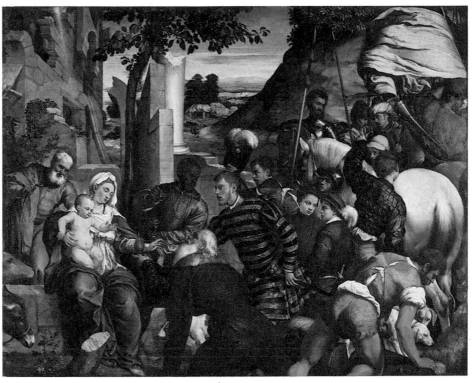

1. Bassano: The Adoration of the Kings

2. Batoni: The Sacrifice of Iphigenia

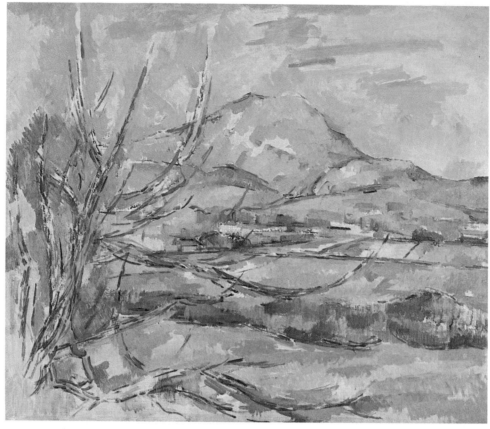

3. Cézanne: La Montagne Sainte-Victoire

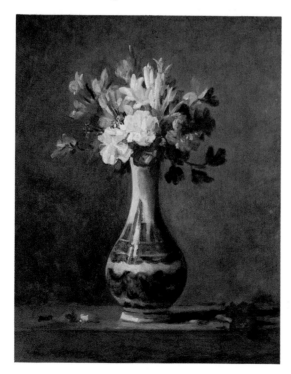

4. Chardin: Vase of Flowers

BONNARD

Pierre Bonnard (1867-1947) was a close friend of Vuillard (q.v.), and during the 1890s they were both painting in flat, fairly simple areas of colour, a style inspired partly by Gauguin's *Vision of the Sermon* of 1888. It is seen beautifully used in Vuillard's *La Causette* of about 1892.

Lane at Vernonnet

This picture was painted after 1912, probably between then and 1914. Vernonnet is in the Seine valley between Paris and Rouen. The organisation of the picture in bold, simple areas comes from Bonnard's earlier experience. But each area is alive with a continual variation of colour and brushwork, which is reminiscent of Gauguin's treatment of his *Martinique Landscape.*

BRIL

Paul Bril (1554-1626) was born in Antwerp but from 1582 he worked in Rome. Most of his paintings are landscapes painted on a small scale.

Landscape with Figures

It is dated 1598, and is painted in the convention of the late 16th century. The landscape is imaginary, and the painter has constructed it layer by layer, from the browns of the foreground to the warm clear blue of the distance. The effect is that of a charming and brittle fairy-tale, wholly convincing but quite untrue. This convention has almost as close a kinship with, for example, the background of the Massys *Portrait of a Notary* as it has with the landscapes of Claude or even the later work of Bril himself.

BUTINONE

Bernardino Butinone (active 1484-1507) was working in Milan while Leonardo da Vinci was there, but before Leonardo had dominated the Milanese tradition. He was influenced by the Paduan painters.

Christ disputing with the Doctors

Painted about 1480. It originally belonged to an altarpiece containing about twenty scenes from the life of Christ, most of which are known. The scene is set in a Renaissance room in which Christ sits on a dais of very curious and unusual design.

CEZANNE

Paul Cézanne (1829-1906) learned first from Courbet's realism, then absorbed impressionist ideas through contact with Pissarro. From the age of about 45 he worked mainly in Aix in the south of France. There he developed—very nearly in isolation—an art of painting which was to be the richest source of inspiration for the painters that followed him, from the time they first came to know it at the end of his life.

La Montagne Sainte-Victoire *opposite 3*

It was probably painted about 1900-02. Cézanne had abandoned thick opaque paint in order to build up his pictures with thin glazes, allowing the white of the canvas behind them to give them luminosity. The atmosphere is characteristic of his beloved "grey days", when the colours changed comparatively little. The mountain was a subject to which he continually returned, its rising mass and the flat ground in front presenting a continuous surface which could be defined only by the relationship between the colours on it. In creating the progression of blues and browns that contains this sense of the receding forms, Cézanne built up on the surface of the canvas a colour sequence endowed with extraordinary tension and vitality.

CHARDIN

J.-B.-S. Chardin (1699-1779) lived and worked in Paris. He became a respected and valued member of the Paris Academy, to which he was admitted in 1728. Connoisseurs in France and abroad bought his pictures, usually after they were exhibited in Paris. He painted mainly still-life and tender and unaffected bourgeois interior scenes of a kind familiar to him in his own household.

Vase of Flowers *opposite 4*

This justly famous painting of carnations, tuberoses and sweet peas, is Chardin's only known flower-piece, although one or two others are recorded. It is hard to find in the rest of his work any problem akin to the interpretation of the fragility of petals. It may be that this was a special commission, or an experiment that he did not pursue. It probably dates from the early 1760s.

CHURCH

Frederic Edwin Church (1826-1900), an American artist, studied with Thomas Cole (1801-48), the founder of the Hudson River School. Church was famous in his lifetime for his pictures of American and Arctic scenery.

Niagara Falls, from the American Side

This is possibly the most important American painting outside the United States. It was presented to the National Gallery by an expatriate Scot from New York, John S. Kennedy, in 1887. There are twenty known paintings including oil sketches of the Falls by Church. The first time he saw them was possibly in 1847. He made three visits in 1856 before painting the view of the Falls from the Canadian side which is now in the Corcoran Gallery of Art in Washington. The present view of the Falls, commissioned for the Paris *Exposition Universelle* 1867, but never shown there, was based on a sepia photograph and on sketches made some ten years earlier.

CIMA

Cima da Conegliano (*c.* 1459-*c.* 1517) is said to have worked in Conegliano until 1489. He was in Venice 1492-1516. He was perhaps a pupil of Giovanni Bellini, and was certainly influenced by him.

The Virgin and Child with Saints Andrew and Peter

This is an unfinished picture. The white gesso ground remains untouched in the right-hand part of the sky. The figures were first drawn in with a brush, and St Peter is left in this state. The Virgin and Child are almost finished in tempera. Although the landscape behind, the sky and the foreground figures remained almost untouched, the space between the three main figures was of such importance to the artist that he had, even at this stage, painted in very deliberately the ground and rocks between them. The uneven ageing of the parts painted in oil-paint, and some later re-painting (the blue in the sky, and possibly the dark brown in the landscape) tend to obscure Cima's sensitivity to this idea of spatial interval.

BONNARD
BRIL
BUTINONE
CEZANNE
CHARDIN
CHURCH
CIMA

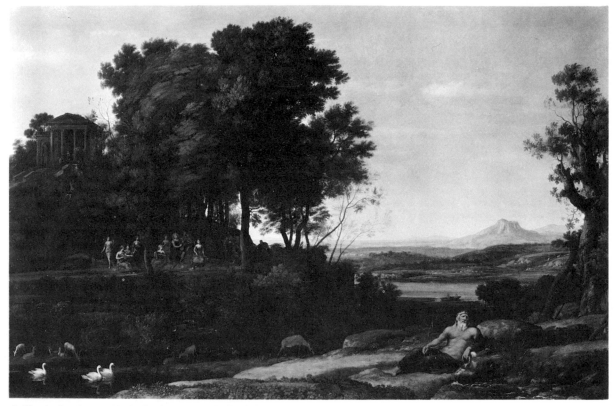

5. Claude: Landscape with Apollo, the Muses and a River God

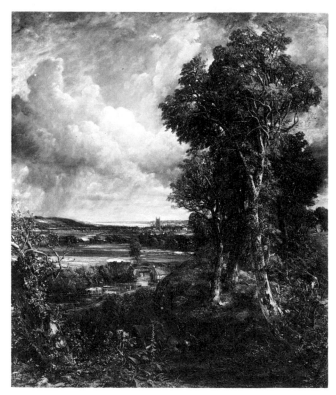

6. Constable: The Vale of Dedham

CLAUDE

Claude Lorraine (1600-1682) was born in the Vosges, but by about 1613 he was in Rome, where he remained. He created a form of idealised landscape, evoking an atmosphere rather than a particular locality, which was greatly admired in 18th-century Britain, as it still is, and his painting had a strong influence on landscape painting here.

Landscape with Apollo, the Muses and a River God *opposite 5*

This picture was painted for Cardinal Pamphili in Rome in 1652. It was in England by 1777, in the collection of Lord George Cavendish, from whose descendant it was bought in 1960. It has since been cleaned. The landscape is derived, as in many of Claude's paintings, from his intensive study of the countryside around Rome. Apollo sits among the Muses on Mount Helicon playing his lyre, while five poets come up behind to listen. At the top of the mount is the temple of the Muses. The design cuts the canvas boldly in two, the dark mass of hill and trees opposing the light expanse of sky. At one place, at the centre of the design, these dark and light areas are made to overlap at full strength, where the bright sky runs behind the tree trunks and the silhouette of the poet approaching the Muses. Round the side, foreground and distance are drawn together in a single long, uninterrupted phrase. The ground recedes continuously from the brisk foliage and sparkling water beside the River God, across the river and the rocks and buildings beyond it and out over the walled town and the distant hills, until at last land and sky are hardly distinguishable.

CLOUET

Jean Clouet (active 1509; *d.* 1541) was probably born in the Netherlands, but he worked in France, at Tours from 1516 and later in Paris, where he died. He was court-painter to Francis I. His son, the better known François Clouet, succeeded him in the same office.

Madame de Canaples

Most of Clouet's work was in making portraits of the royal family and of the French court, of which Madame de Canaples was a distinguished ornament. The sitter was probably painted about 1523, a year or two before her marriage. Clouet worked from a drawing (now at Chantilly), which he had made from life of the head only, and from written notes of the colours and of the sitter's dress. At this date full-length portraits were rare, and the convention of showing the sitter with his hands resting on a ledge or as though on the bottom edge of the painting was very commonly adopted. (The original paint on the face is worn and has been retouched.)

CONSTABLE

John Constable (1776-1837) was born in Suffolk and dedicated most of his life to painting part of the Stour valley on the borders of Essex and Suffolk. He studied particularly the formation of clouds and natural effects of light and weather.

The Vale of Dedham *opposite 6*

It shows the river Stour, under a morning light, meandering towards the village of Dedham and Harwich estuary beyond. It is one of his studio pictures, painted in 1828 and exhibited in that year in the Royal Academy. Constable referred to it in a letter of June 11th: "I have painted a large upright landscape, perhaps my best". He had been in Essex in the spring, and no doubt revisited the site, but the design is based on a small sketch which he had painted in 1802 (now in the Victoria and Albert Museum). Another circumstance is illuminating. Although he did not, like Turner, model himself on Claude, Constable was deeply impressed by his landscapes, and had copied some. The first one he saw was a small landscape with Hagar and the Angel (now in the National Gallery, London) belonging to Sir George Beaumont, who befriended Constable as a young man. Constable made a copy of it in 1799, and its size and composition are so close to the sketch of 1802 that there is no doubt that Constable was "doing Claude over again from nature".

COROT

Camille Corot (1796-1875) never allied himself directly with any of the artistic movements he lived through, from neo-classicism to the first stages of impressionism, but his training in Paris was neo-classical, and he came later to share many of the ideas of Courbet and of the Barbizon painters. Most of his life he was working in or near Paris.

Entrance to a Wood

This is probably one of his early pictures, painted while he was still working intermittently as an art student in Paris, shortly before he went to Rome in 1825. It is one of a number of landscapes painted in the neighbourhood of Ville d'Avray, to the south of Paris, where his parents had a house.

CRANACH

Lucas Cranach (1472-1553) was working from 1505 in Wittenberg as court painter to the Electors of Saxony. He painted principally devotional pictures and portraits for the court. For the residences of the Elector he painted a series of nudes representing Venus, Lucretia, Diana and others.

Venus and Cupid

Painted before 1537. It is one of a number of variants on a life-size picture now in Berlin. Common devices in Cranach's beautiful, if almost over-civilised, art are the black background and wisps of diaphanous drapery, used as foils to the naked figure.

CROME

John Crome (1768-1821) lived and worked mainly in the neighbourhood of Norwich. He and Cotman were the leading artists of the Norwich school of landscape painters of the early 19th century.

The Beaters

It was painted about 1810, in the same year as Turner's *Somer Hill*. It owes much to the vision of Hobbema, and it is revealing to compare it with the much earlier *Landscape with Cornard Village* by Gainsborough, which was also inspired by the Dutch. The design is established by a quietly stated set of visual elements in opposition: the bright sky and flat, open ground against the dark mass of the wood with its vertical accents in the tree-trunks.

CUYP

Aelbert Cuyp (1620-1691) worked in Dordrecht mainly as a landscape painter, at first in the style of Jan van Goyen. From the mid 1640s he developed the golden-toned landscapes for which he is best known. They were inspired by the style developed by Cuyp's contemporaries who went from Holland to work in Italy, like Berchem, although Cuyp does not seem to have visited Italy himself. His pictures were greatly appreciated by British connoisseurs from the middle of the 18th century.

Landscape with a View of the Valkhof, Nijmegen *opposite 7*

This picture is characteristic of Cuyp's mature style. The ruins of the castle, which was built by Charlemagne, are illuminated by the glowing evening sun. In reality the castle stands on a hill above the river, but Cuyp has reduced the difference in levels in order to achieve an extensive view across flat ground and the sense of space that this gives. The picture is known to have been in an English collection by the middle of last century.

DAVID

Gerard David (*c.* 1460-1523) was working in Bruges from 1484, and became the principal painter of the city after Memling's death in 1494. Although a contemporary of artists working in the Renaissance style, like Massys in Antwerp, he was most strongly affected by the art of the 15th century, and was the last great painter in the tradition started by Jan van Eyck.

Three Legends of Saint Nicholas *opposite 8*

St. Nicholas of Myra, the patron saint of children, is familiarly known as Santa Claus. (i) He stands upright on the day of his birth and gives thanks to God for giving him life. (ii) Surreptitiously, he throws bags of gold through the window of an impoverished nobleman to provide dowries for his three daughters. (iii) As Bishop of Myra, he brings back to life three boys killed and salted down as meat by an inn-keeper in a time of famine. These panels reveal the characteristically Flemish delight in the contemplation of simple visual fact, like the tiles on the floor, the wood-grain of the salting tub and the splendid bishop's robes and crozier. But they show, too, David's clear sense of the solidity of objects and people and of the space they occupy. They belonged, with three similar panels of St. Anthony (now in Toledo, Ohio), to an altarpiece of the 'Virgin and Child with St. Anne' (now in Washington), dating from 1500-1510 when this subject was a popular one in the Netherlands.

DEGAS

Edgar Degas (1834-1917) received an academic training in drawing, and greatly admired the work of Ingres, whom he knew as an old man. His vision was modified by the impact of Courbet and later by the colour of the impressionists, amongst whom he refused to count himself. He was the only painter of his generation who admired Gauguin's Tahitian paintings.

Diego Martelli *following page 9*

This portrait was painted in 1879. Martelli, a Florentine writer and critic, was among the first to collect impressionist paintings, and to write in their defence. The relationship between the blues and whites on the table was a part of the interest Degas had caught from the impressionists. The unexpected placing of Martelli on the canvas, and the angle from which we are made to look down on him, are decisions which were determined for Degas by the character of the plump, cross-legged Florentine, and he

makes these elements of composition contribute towards our understanding of the man's personality.

Before the Performance

Probably painted in the early 1880s, it shows dancers practising independently on the stage. Degas here accepts the colours he has seen, but heightens them, accentuating the garish unreality of arms and faces under the gas-lights. Very different is the colour of the *Group of Dancers,* which must date from the 1890s. Here the scheme of cold whites against green and orange is entirely arbitrary. The picture shows at its best Degas' power to use an accident of grouping that could be seen only momentarily, transforming it into an enduring image.

Woman drying Herself

This is one of many pastels Degas made of women at their toilet during the 1890s. "Perhaps," he said later, "I have regarded woman too much like an animal." But he said it without remorse. It was his strong sense of realism that made him constantly alert to the most ungainly phases of movement in the human figure, so carefully avoided in academic painting.

Nude Study of a 14 year old Dancer (bronze)

This is a study for a larger wax figure which Degas exhibited, dressed in real clothes, in 1881. Virtually all Degas' bronzes were cast after his death from wax figures he had made but never exhibited. They all date from the latter half of his career. The English painter Sickert tells a story of a visit to Degas' studio, which reveals vividly the terms in which Degas conceived the form of his figures. "He showed me a little statuette of a dancer he had on the stocks, and–it was night–he held a candle up, and turned the statuette to show me the succession of shadows cast by its silhouette on a white sheet."

7. Cuyp: Landscape with a view of the Valkhof, Nijmegen

8. David: Three Legends of Saint Nicholas

DELACROIX
DOMENICHINO
VAN DYCK
ELSHEIMER
FERRARESE
SCHOOL

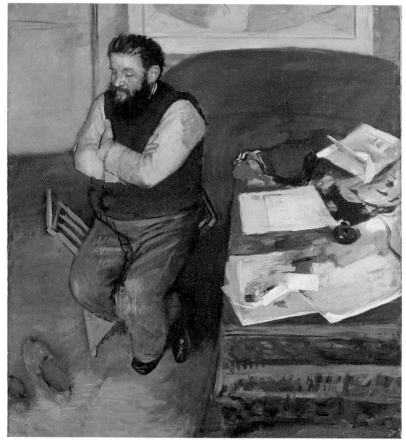

9. Degas: Diego Martelli

10. Elsheimer: The Stoning of St. Stephen

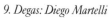

11. Delacroix: Vase of Flowers

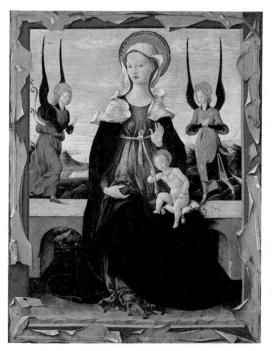

12. Ferrarese School: Madonna and Child with Two Angels

DELACROIX

Eugène Delacroix (1798-1863), a key figure in the Romantic Movement although he himself was suspicious of the label "romantic". His influence, especially as a colourist, on late 19th-century French painting was enormous. He is in the line of Rubens whom he admired, a painter of vast decorative schemes which illustrate heroic actions and great themes from contemporary history and literature, especially from Scott and Shakespeare. He had a brilliant and highly cultivated mind as his Journal and letters show.

Arabs playing Chess

Painted in 1847, it is a souvenir of Delacroix's visit to North Africa in 1832. It was one of the most important events of his life and the exotic surroundings and the light under which he saw them had a lasting effect.

Vase of Flowers *opposite 11*

It is a painting of dahlias principally, and dates from 1833. Pictures of flowers form a small but significant part of Delacroix's output and this is the earliest that is known. It has the quality of an oil sketch in its spontaneity and brilliance of handling. Referring to Delacroix's personality Baudelaire once wrote about "a volcanic crater artistically concealed behind bouquets of flowers".

DOMENICHINO

Domenico Zampieri (1581-1641), known as Domenichino, was born in Bologna. In 1602 he settled in Rome, where he became the favourite pupil of Annibale Carracci, who was also from Bologna.

The Adoration of the Shepherds

It was probably painted about 1610 and is based on a picture by Annibale Carracci which has since been lost. Domenichino keeps firmly within the classical tradition that goes back to Raphael. The grouping of the figures and the movements of their arms lie across the flat surface of the picture and give it emphasis, just as the young shepherd playing his bagpipe emphasises the frame by standing right up against it. Attention is focussed on Christ, whose head lies exactly at the centre of the design, and who sheds a radiance on the tight group of heads round Him. This kind of design was to exercise a great influence on Poussin, who came to Rome in 1624, and its essential characteristics survive in his *Seven Sacraments*. The opposing concept, in which the emphasis is thrown onto the depth and lighting of the pictorial space rather than the design on the surface, is clearly seen in the Rubens *Adoration of the Shepherds* painted at almost the same time.

VAN DYCK

Sir Anthony van Dyck (1599-1641) was the most gifted pupil of Rubens (q.v.). He came to England in 1632 at the invitation of Charles I, bringing a more courtly and magnificent conception of portraiture than had hitherto been seen there. He remained in England for the rest of his life, engaged in a highly successful practice as portrait painter to the king and court.

St. Sebastian bound for Martyrdom

It is one of several versions of this theme painted by van Dyck. X-rays show that it began very like an early design (now in the Louvre, Paris) but was substantially altered. The two executioners were moved across from the right-hand side to make room for the soldier with the red banner, whose horse repeats a horse in the Rubens 'Coup de Lance' (Antwerp) on which van Dyck had recently been working. This canvas, painted about 1621, was not taken further than a full-sized, highly finished sketch. A more complete but less lively painting based on it is in Munich.

The Lomellini Family

After leaving Rubens' studio, and before he settled in England in 1632, van Dyck spent the years 1622-27 in Italy, mostly in Genoa, where this was painted. It probably represents members of the family of Giacomo Lomellini 'il Moro', who died *c.* 1653-56. Wilkie saw the picture 'fitted into the wall' in one of the palaces of the Lomellini in Genoa (very likely its original position), and described it in a letter to Andrew Wilson, who bought it for the Royal Institution, the forerunner of this Gallery.

ELSHEIMER

Adam Elsheimer (1578-1610) was a German painter who began in the Flemish tradition. He was in Rome by 1600, and spent the rest of his short life there. He worked on a small scale, and his designs had a strong influence on his contemporary Rubens, and on later painters, especially Claude and Rembrandt.

The Stoning of St. Stephen *opposite 10*

This picture came to light in a private collection in Scotland in 1965. The first Christian martyr is seen in his deacon's robes, and in the sky is his vision at his martyrdom: "Behold, I see the heavens opened, and the Son of Man standing at the right hand of God." The painting, which dates from about 1602/5, is on a silvered copper ground, whose brightness lends the colours some of their unusual brilliance and carrying power.

Il Contento

It was received by the Gallery in 1970 from H.M. Treasury, who had accepted it in part payment of death duties. It is perhaps Elsheimer's masterpiece, painted about 1607. Jupiter, angry with mankind because they worshipped 'Contento' the goddess of happiness above all others, came down during a feast in honour of the goddess and carried her away. The people tried to hold her back by her robe, but Jupiter had substituted her sister the goddess of discontent in the clothes and left her behind instead. Most remarkable in a work on this scale is the range of Elsheimer's visual effects, from the dramatic light and shadow of the heads at the left to the gentle greens and greys of the girls who form a chain at the right-hand edge.

FERRARESE SCHOOL

This name is used to describe the group of painters employed by the Este family at the ducal court of Ferrara, some 40 miles to the south of Padua. In the second half of the 15th century their work was strongly influenced by the Paduan painters, especially Mantegna. The best known at this time were Cosimo Tura, Francesco Cossa and Ercole Roberti.

Madonna and Child with Two Angels
opposite 12

This picture was painted in the later 15th century, possibly by one of the professional miniature painters employed at the court. There is a courtly preciosity in the interplay of pale crimson and scarlet, in the slenderness of the angels' wings and in the agitated folds of the Madonna's scarf. The picture is seen as though through the torn edges of a sheet of vellum.

DELACROIX
DOMENICHINO
VAN DYCK
ELSHEIMER
FERRARESE
SCHOOL

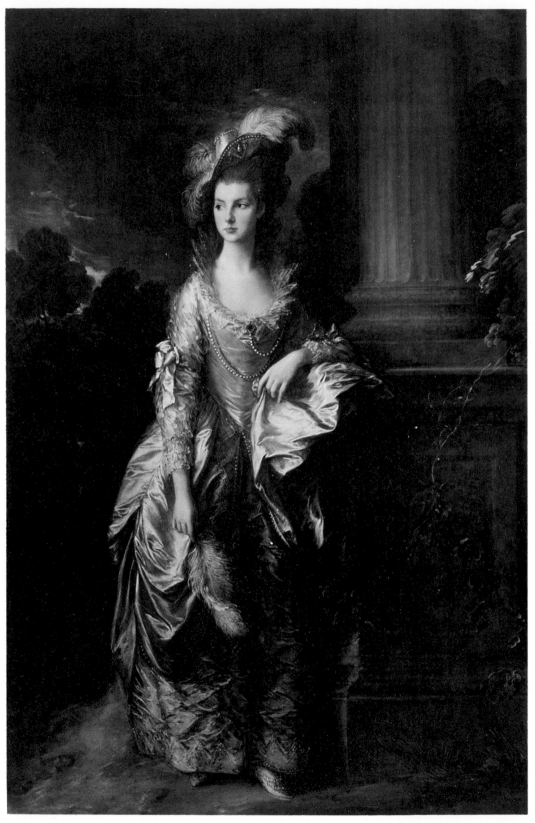

13. Gainsborough: The Hon. Mrs Graham

GAINSBOROUGH

Thomas Gainsborough (1727-1788), who was born in Suffolk, returned there after a period of training in London, and worked in Ipswich from 1753 until he went to establish himself as a portrait painter in Bath in 1759. (A fine portrait from the Bath period is the *4th Duke of Argyll* in the Portrait Gallery.) From 1774 he was working in London.

Landscape with distant View of Cornard Village

It dates from about the middle 1750s. Cornard is close to his native town of Sudbury. The English amateurs of painting were enthusiastic collectors of the Dutch landscapes of the 17th century, and in these years it was on the Dutch that Gainsborough based his conception of landscape painting. The composition of this picture and the clear feeling it contains of the interval between foreground and distance derive unmistakably from painters like Jacob Ruisdael (q.v.). But Gainsborough sees it through his own eyes, and he introduces an Arcadian gaiety in the colouring, which is enhanced by the evident contentment of the cows and milkmaids that inhabit the scene.

The Hon. Mrs. Graham *opposite 13*

It was begun early in 1775. Gainsborough had recently moved from Bath in order to continue his practice in London. A comparison with the style of the Cornard landscape reveals how much he had learned in between from the study of Van Dyck. When the sittings began, the Hon. Mary Cathcart had recently married Thomas Graham of Balgowan, who commissioned the portrait, and she was then 18. In June 1775, Mrs. Graham's drawing-mistress wrote to her: "Gainsborough has not advanced your picture a single stroke, and saies he has no thought of finishing it within the twelve month, if he did not add that it shall be the compleatest of pictures, I should cry at the delay." That Gainsborough himself thought well of it is evident from the fact that it was one of the pictures he showed in the Royal Academy of 1777. He had withheld his work from the recently formed Academy since 1772 because of disagreement with Reynolds over the hanging of pictures. After this lapse of four years it was important for him to return with a flourish, and he did. Mrs. Graham died in 1792, and her husband, who later became Lord Lynedoch and one of Wellington's leading generals, was so grief-stricken that he had the portrait stored in a London warehouse. It was not seen again until his death in 1834. His heir bequeathed it to the Scottish nation.

Rocky Landscape

This was painted towards the end of Gainsborough's life, about 1783. The contrast is almost complete between this romantic view and the much earlier landscape. The Suffolk scene, for all its touching Arcadian atmosphere, has a basis of factual reality. The *Rocky Landscape* is an imaginary view, based partly on the 'sublime' landscapes of Gaspard Dughet and Salvator Rosa. The arrangement of the composition, with its curious and characteristic illogicalities of scale, suggests that Gainsborough derived another part of his inspiration from his famous sand-table, on which he constructed miniature landscapes "composed of broken stones, dried herbs, and pieces of looking glass, which he magnified and improved into rocks, trees and water". Another contrivance that he had recently begun to use was a 'showbox', with which he would entertain his friends. This was a box that held landscapes painted on sheets of glass, which were then illuminated from behind by candlelight shining through coloured silk screens. It seems likely that this was the source of the elusive, flickering colours in the trees and rocks of the foreground. But Gainsborough's landscapes were no less true for being artificially contrived. Constable, who was to learn so much from them, said: "The stillness of noon, the depths of twilight and the dews and pearls of the morning, are all to be found on the canvases of this most benevolent and kind-hearted man."

GAUGUIN

Paul Gauguin (1848-1903) was painting in his spare time from 1874, and did not give up the Stock Exchange to devote himself to art until 1883. Under Pissarro he learned to paint in the impressionist idiom. After 1891 he spent most of his life in Tahiti and the Marquesas, where he painted images of native life. He and van Gogh were at first the strongest influences on the painters of the next generation, among whom were Pierre Bonnard and Henri Matisse.

Martinique Landscape

This is the most important of the landscapes Gauguin painted during June and July 1887, on a short visit to Martinique. It has a strong sense of atmosphere, but what it reveals is not a particular view on a particular hot afternooon, but a synthesis of the sun-drenched landscape. The sense of depth and distance is severely reduced; the colours are applied in small vertical strokes to present an appearance rather like the weave of tapestry;

and in the foliage Gauguin has looked for an equivalent in clear, flat shapes. All of this foreshadows the stylisation of *The Vision of the Sermon* of the following year.

The Vision of the Sermon (Jacob Wrestling with the Angel) *page 3*

It was painted in 1888 at Pont-Aven, Brittany, where Gauguin spent most of his time before he went to Tahiti in 1891. It was the first picture in which he completely turned his back on the direct interpretation of optical effects. The Breton peasant women and their parish priest are brought together on the same canvas with the vision they see in their minds. Gauguin wrote at this time: "Do not copy too much from nature. Art is an abstraction; derive it from nature by indulging in dreams in the presence of nature." The boldness of design and treatment was inspired by the Japanese woodcuts that had recently excited great interest in Paris. The ability to hold the strong vermilion field in its place behind the reticent colours of the foreground was learned from the impressionists.

Three Tahitians

This picture was painted in Tahiti in 1899. In March of that year, when Gauguin wrote explaining his conception of painting, he might almost have had this picture in mind. Speaking of his figures he says: "... something antique, august, sacramental in the rhythm of their pose, in their strange immobility. In eyes that dream, the troubled surface of an unfathomable enigma." And of colour he says: "These repetitions of colours, monotonous harmonies ... are surely analogous to those oriental chants sung in a strident voice to the accompaniment of resonant sounds, close in pitch, which intensify them by contrast."

GIULIO ROMANO
VAN DER GOES
VAN GOGH
GOYA
EL GRECO

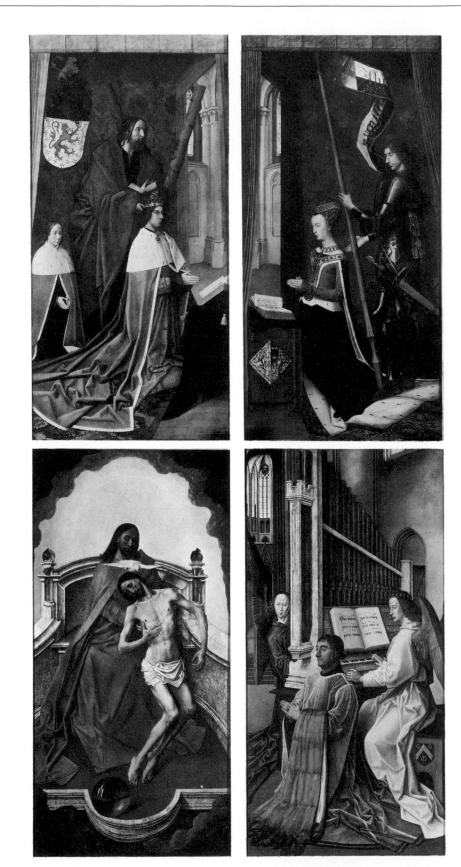

14. van der Goes: The Trinity Altarpiece

GIULIO ROMANO

Giulio Pippi, known as Giulio Romano (c. 1499-1546) was born in Rome and worked there as an assistant to Raphael, until the latter's death in 1520, when he took over the artistic direction of the workshop. In 1524 he left Rome to become court painter at Mantua, where he was also employed as an architect.

The Virgin and Child with the Infant Baptist

This picture was probably painted about 1521. It is based on a design by Raphael (of which the evidence is a picture in the Prado, Madrid) which Giulio has adapted and developed in a wholly creative and individual manner. The hard and brittle modelling and pale porcelain-coloured flesh tones, the vivid local colours of the draperies, and above all the overpowering architectural background (absent from Raphael's prototype) are each distinctive features of Giulio's inimitable style. Raphael's idealised, but still intensely animated human figures are here removed from their original neutral, timeless setting and transferred, brittle and unreal, deprived of natural vitality, to an inescapably archaeological environment.

VAN DER GOES

Hugo van der Goes (active 1467-1482) worked in Ghent. His most important surviving work, the Portinari altarpiece, was painted for a church in Florence, where it astonished his Italian contemporaries by its intense and earthy realism. In 1475 he entered a monastery in Brussels, but continued to paint. He died insane in the monastery.

The Trinity Altarpiece *opposite 14*

These panels were probably commissioned for the church of the Holy Trinity in Edinburgh (now demolished) by Sir Edward Bonkil who was its first Provost. They are likely to be the wings of an alterpiece and are now mounted in such a way as to demonstrate their correct relationship not only to themselves, when closed, but also to the missing centre panel (perhaps representing the Virgin enthroned and presumed destroyed at the Reformation), when open. When closed the wings show Sir Edward kneeling in prayer whilst clouds open in front of him to reveal a vision of the Holy Trinity. When open they show the royal family kneeling on either side: to the left James III with St. Andrew beside him and his son the future James IV behind; to the right the Queen, Margaret of Denmark, with a saint in armour who is evidently St. George. James and Margaret were married in 1469

and their son James was born in 1473. The panels were probably painted some time between 1475 and 1479. The best, and the best preserved, is that of Sir Edward Bonkil kneeling in front of an organ. The beautiful expressive folds of his robe and of the angel's behind him are held back with the rest of the colouring of this panel to a delicate series of whites, greys and soft greens to enhance the blazing gold and crimson of the Holy Trinity itself. Bonkil evidently went to Flanders himself to commission the panels, and the painting of his head and hands has the authenticity of a direct study from life. The circumstances in which the Royal heads were painted are not clear, but it is certain that the head of James III, as we see it now, was not painted by van der Goes himself.
(Lent by Her Majesty the Queen)

VAN GOGH

Vincent van Gogh (1853-1890) tried first the careers of art dealer, schoolmaster and lay preacher. He went to Paris in 1886, where he absorbed the impressionist doctrine. Nearly all the large number of paintings in his developed style date from a period of less than two years.

Head of a Peasant Woman

It was painted in 1885, before van Gogh went to Paris or learned anything of impressionism, while he was working in Nuenen, a village in south Holland. Of his studies of Dutch peasants at this time, he said he was trying to "paint with earth", to make their faces "the colour of a very dusty potato".

Orchard in Blossom

This picture was painted when van Gogh went to Arles in the south of France in the spring of 1888. He had spent the previous two years in Paris, where his ideas on painting were turned upside down by his contact with impressionist and post-impressionist painters, and by the study of Japanese prints.

GOYA

Francisco de Goya (1746-1828), who was of an unpredictable and sometimes violent temperament, trained in the 18th-century Italian tradition of decorative and religious paintings. The effects of the Civil War in Spain and the onset of deafness left him with a sense of isolation. His later painting and graphic work became a bitterly ironical commentary on the state of society, expressed with a rare mastery of the language of form and colour.

El Medico (The Doctor)

Goya was working in Madrid from 1775, and part of his work there up to 1791 was designing for the Royal Tapestry Factory. This was one of a set of eleven designs for tapestries to be hung in a palace near Madrid. It was a design for an overdoor and it was delivered to the factory in 1780. The subject of the doctor warming his hands at a brazier with his students standing behind him is treated in a romantic spirit that owes much to Tiepolo (q.v.) and the Venetian tradition. The changes in tension from the subdued blue of the sky to the scarlet cloak and the sharp brightness of the books are heightened by sympathetic changes in the character of the painted shapes and in the varying thickness and texture of the paint itself.

EL GRECO

Domenico Theotocopuli (1541-1614), known as El Greco (the Greek), was born in Crete. He trained in Italy, part of the time under Titian in his last years. He went to Spain about 1576 and settled in Toledo for the rest of his life. His paintings, many of which were executed for religious communities in Spain, are visionary and intensely personal.

The Saviour of the World

It was in the nature of El Greco's practice as a painter that he should be called upon to paint the same subjects a number of times. And it was inevitable, in pictures that depended on the intensity of the painter's vision, that the different versions should vary in quality. This painting belonged to an 'Apostolado', a series of thirteen canvases representing Christ and the twelve Apostles. It was El Greco's first experiment in this design, painted probably at the end of the 1590s, and the image of Christ has the emotional force of an authentic vision. Two later series of this kind by El Greco are known, one of them in Toledo Cathedral.

Fábula

It shows a boy blowing on a charcoal to light his candle. Profane subjects are rare in El Greco's work and the meaning of this scene is a matter for conjecture. It may represent the recklessness of youth in burning up the candle of life, whilst the grinning man and the monkey (often used as a symbol of foolishness) give him encouragement. The sickly face of the youth, with its accents of carmine in the lips and nostrils, is given the haunting appearance of a mask in the flickering light of the charcoal.
(Anonymous loan)

GIULIO ROMANO
VAN DER GOES
VAN GOGH
GOYA
EL GRECO

17

GUARDI

Francesco Guardi (1712-1793) was the best known of the Venetian view painters after Canaletto. Most of his pictures were painted for the tourists who visited Venice, many of them from Britain.

View of the Piazza San Marco, Venice
opposite 15

It shows long shadows from the late afternoon sun thrown across groups of Venetian gentry standing about in the square in front of St. Mark's Cathedral. Guardi breathes a sense of life and movement into the scene by his flickering highlights and the tiny accents of colour in his figures.

HALS

Frans Hals (1580/81-1666) worked exclusively as a portrait painter. The lively realism with which he presented his sitters and the distinctive flourish of his handling made his portraits popular in Haarlem, where he worked. He painted a number of large portrait groups.

Portrait of Verdonck

It is among Hals' earlier known works. A contemporary engraving of the picture was accompanied by a quatrain to this effect: "This is Verdonck, the tough fellow, whose jawbone attacks everyone. He cares for nobody, great or small–that's what brought him to the workhouse." In the last century Verdonck's disordered hair and the jawbone in his hand seem to have offended the owner of the picture, who had a large claret-coloured cap painted in over the head, and the jawbone metamorphosed into a wineglass. In this state it was presented to the Gallery, in 1916, as 'The Toper'. The cap and glass were removed in 1927.

Portraits of a Gentleman and his Wife

They were painted in the middle 1640s. Except for some of the single and group portraits of his middle years, which were colourful at times to the point of garishness, Hals shrewdly restricted his palette. In this pair, only four pigments are apparent, except perhaps in the green of the lady's fan, and he probably used no more. They are black, white, ochre and an earth red. Hals was unusual in his time for the extent to which he developed his pictures continuously from the beginning, instead of building them up in a number of successive layers. By this method and by limiting his colours, he was able to concentrate on the freshness and vigour of the drawing, in which his real strength lay.

HOBBEMA

Meindert Hobbema (1638-1709) was a pupil of Jacob Ruisdael. Most of his pictures were painted before he was thirty, after which he became a gauger of wine casks. His landscapes are usually seen under a clear sky, their interest and atmosphere depending much on the shapes and disposition of the trees.

Wooded Landscape with Cottages amid Trees *opposite 17*

This picture may be confidently dated to the early 1660s. It demonstrates Hobbema's mastery in the rendering of woodland, on which his reputation as a painter largely depends. His understanding of trees was profound and in the present landscape their form and structure are beautifully realised through a wide diversity of greens, ochres and yellows. Imposed on this seemingly casual view of the natural world however, is a design of baroque grandeur and sophistication. Hobbema's influence on landscape painters, Scottish as well as English, was enormous. For example, Alexander Nasmyth's son, Patrick, was nicknamed "the English (sic) Hobbima". His naturalism leads directly to Constable, while his view of landscape is still to a large extent that cherished by many people today.

A View of Deventer
It is identified by the Bergkerk seen behind the wall. It is not known how closely Hobbema followed the rest of the scene. It was usual for painters at this date to make extensive adjustments to the view they saw in order to improve its composition.
(Duke of Sutherland loan)

HOGARTH

William Hogarth (1697-1764), in spite of his ambition to be a great history painter, is best known for the several series of what he called "modern moral subjects", the first of which appeared in 1732 under the title of 'A Harlot's Progress'. It was not until 1740 that he turned his hand seriously to painting portraits. These are distinguished by a direct, virile and sympathetic sense of the sitter's personality.

Portrait of Sarah Malcolm

Many of Hogarth's paintings beside the 'Progresses' were produced as prototypes for himself or another engraver to work from, and the engravings were sold in fairly large numbers. Until the press photographer replaced him, the engraver was always sure of a brisk sale of prints representing the likeness of notorious criminals. Sarah Malcolm was executed in 1733 for the murder of her mistress and two fellow-servants. Hogarth visited her in Newgate Prison with Thornhill, his father-in-law and teacher of painting, and issued engravings of her based on the painting.

HOLBEIN

Hans Holbein (1497/8-1543), called the Younger to distinguish him from his father, was born in Augsburg and settled in Basle. He first visited England in 1526 and returned to settle in 1532. He painted murals and altarpieces and made designs for craftsmen in every media. He is best remembered however for his portraits, especially those he painted of members of the court of Henry VIII, whose service he entered about 1635/36. Holbein's art is a subtle blend of many traditions and influences, both northern and Italian.

Allegory of the Old and New Testaments
opposite 16

This picture illustrates one of the most important themes in the pictorial art of the Reformation. It is strongly Lutheran in character. Naked Man with Isaiah and John the Baptist in the centre of the composition is faced with a choice between Law and Grace, the old and new dispensations which are represented allegorically on the left and right halves of the picture. Reliance on the Law which Moses received on Mount Sinai leads to sin and death. Belief in Christ, who conquered sin and death leads to salvation and triumph over death. The tree in the centre is bare on the side of Law but flourishes on the side of Grace. The picture was possibly commissioned for domestic contemplation by some scholar or theologian involved in the religious debate of the 1530s. The subject is about doctrine, its polemical nature more suited, one might imagine, to treatment in a broadsheet than a painting. But Holbein has created a major work of art and the painting of the tree against the sky is especially memorable.

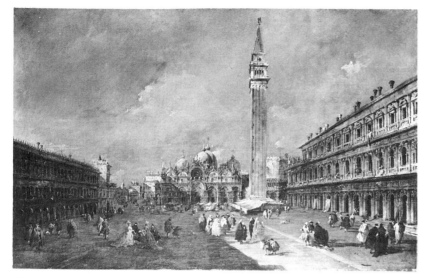

15. Guardi: View of the Piazza San Marco, Venice

16. Holbein: Allegory of the Old and New Testaments

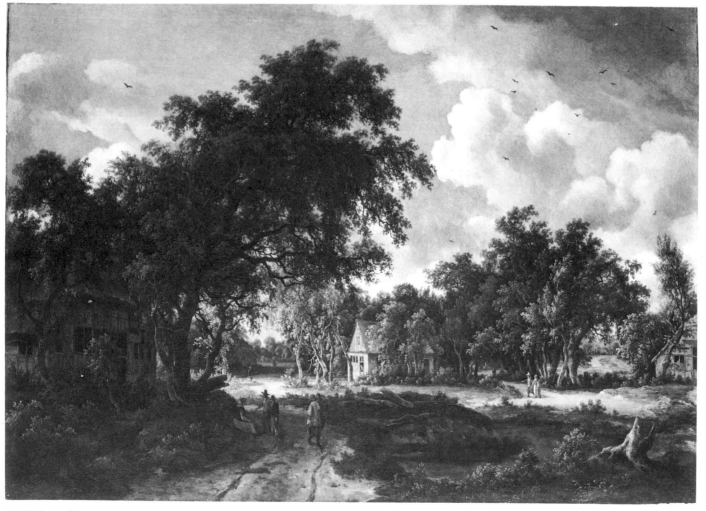

17. Hobbema: Wooded Landscape with Cottages amid Trees

LORENZO
MONACO
LOTTO
MASSYS
MONET
PERUGINO

LORENZO MONACO

Lorenzo Monaco (c. 1370-1422/5) was a Sienese who took his vows in a Camaldolese monastery in Florence in 1391. His early paintings followed the Florentine tradition that was begun by Giotto. Later on he was strongly affected by the decorative use of line and colour of the Gothic painters outside Italy.

Madonna and Child

The Gothic influence is apparent in the bold, exuberant colour scheme of blues, pinks and warm yellow against the gold ground and in the emphasis given to the Madonna's silhouette and the pattern made by the hem of her robe. The figure of the Christ child is more substantial and belongs more clearly to the Florentine tradition. The Madonna's throne, with arms terminating in four lion heads, is the Sedes Sapientiae, which derives from the Throne of Solomon described in I Kings X 18-20. The symbol was rare in Italy, but not uncommon in the 14th century further north. The panel was evidently the centre part of an altarpiece, for the edge of what seems to be the crimson sleeve of a saint survives from the missing left-hand part at the edge of the panel.

LOTTO

Lorenzo Lotto (1480-1556) was born in Venice. He spent considerable periods working outside Venice, in Treviso, Rome, Bergamo and elsewhere. His early work shows clearly the influence of Giovanni Bellini and Antonello da Messina. His later pictures became more agitated in spirit and more complex in structure.

Madonna and Child with Four Saints
opposite 18

This is an early picture, probably painted about 1507/8. The figures, which are both solid and human, take their places in a clear formal design which has been studiously controlled. In the Child's left leg, providing a sturdy upright midway across the canvas, and in the curtain dividing the canvas along its whole length, there is a nicety of calculation which recalls the geometric structure of some of Bellini's pictures. But the division of the picture space caused by the curtain also set an important problem. The only link between figures and landscape is that the light which throws the Madonna and her attendant saints into relief is the same as the light from the sky in the landscape behind the curtain. In making the unity of his whole design depend to this extent on the light, Lotto was isolating the central problem of the Venetian painters. (Duke of Sutherland loan)

MASSYS

Quentin Massys (1465/6-1530) went from his native Louvain before the end of the 15th century to work in Antwerp, which was then the richest and most cosmopolitan of the commercial centres of Europe. Massys became the leading painter of the city in his day, which coincided with the High Renaissance in Italy, with Raphael working in Rome, with the last thirty years of Leonardo's career and the early phases of the work of Michelangelo and Titian.

Portrait of a Notary *opposite 19*

This is an important Renaissance portrait which probably dates from 1510-20. Its setting is a Renaissance balcony with round-headed arches and pillars of classical inspiration, through which we see an enchanting mountainous landscape of a kind that had already appeared in the background of Leonardo's paintings and would return in the paintings of Pieter Bruegel. The notary himself looks out at us almost quizzically, as though in a moment of conversation. He is unmistakably a contemporary of Erasmus in the Netherlands. His identity has not been established, but it is fairly clear that his halo and all the objects in his hands and in front of him, with the single exception of the rosebud, are additions, probably no earlier than the 18th century.

MONET

Claude Monet (1840-1926), originally the leader of the impressionist group, was ultimately left alone to pursue his theories to their logical extreme. His understanding of landscape painting was formed at first under Boudin and later from contact with Courbet and with the painters at Barbizon.

Seascape. Shippping by Moonlight

It is painted over a still-life which is still visible in places and is contemporary with Pissarro's *Marne at Chennevières* with which it should be compared. The comparison however is also with pictures by both artists from the following impressionist decade which are also represented in the collection. The contrast could hardly be more marked. The Monet is a powerful work; those inky blacks and the almost crude manner in which the paint has been applied produce an effect that is expressionist in feeling.

The Church at Vétheuil

It is dated 1878. Comparison with a photograph of the same view shows that Monet heightened the tower to create a more satisfying composition. The painting's perfect condition allows one to appreciate fully the brilliance and originality of Monet's technique. Those dabs of pigment in the foreground sparkle on the canvas and impart an extraordinary animation to this area of painting. Vétheuil is on the Seine, about 30 miles east of Paris.

Haystacks, Snow Effect

This is one of a series of 18 canvases of this subject that Monet painted in 1891, working at them in series every day, so that each should be an unblurred representation of the effect of light and atmosphere at a given hour of the day. It represents a snow scene in bright sunshine and contains an astonishing range of colour from the clear pink in the hayfield itself to the deep red, green and violet in the darker parts of the stacks.

Poplars on the Epte *opposite 20*

It is connected with a similar series of canvases painted to the north of Paris in 1891/2. The tonal range of these paintings is greatly contracted, and nowhere goes very low. The clear sense of the form of the landscape is deliberately lost, by Monet's concentrating his attention on an 'instantaneous' effect of light. This conception of painting, which has no historical parallel, was partly inspired by snapshot photography, which had recently become possible. After the derision that greeted him in the early 1870s, Monet's series met with startling success. The 'Haystacks' were sold out after the first three days at Durand-Ruel's Gallery, for 3,000 to 4,000 francs each.

PERUGINO

Perugino (1446-1523) is called after the city of Perugia where his main works were painted. He seems to have trained under Verrocchio in Florence. He was a master of the serene devotional picture, and the first paintings of Raphael were modelled on his style.

Four Male Figures

This is a fragment, probably the lower left-hand corner of a fairly large classical subject. The picture, one of very few by Perugino that are not devotional, was presumably painted for an apartment in one of the Italian palaces of the Renaissance.

18. *Lotto: Madonna and Child with Four Saints*

19. *Massys: Portrait of a Notary*

LORENZO
MONACO
LOTTO
MASSYS
MONET
PERUGINO

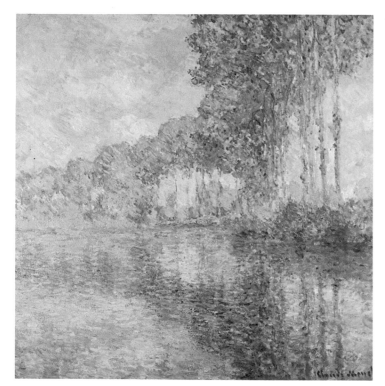

20. *Monet: Poplars on the Epte*

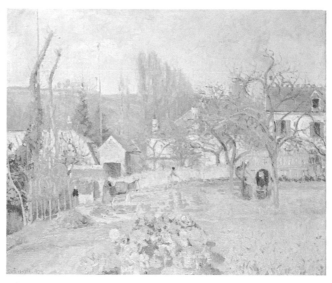

21. *Pissarro: Kitchen Garden at the Hermitage, Pontoise*

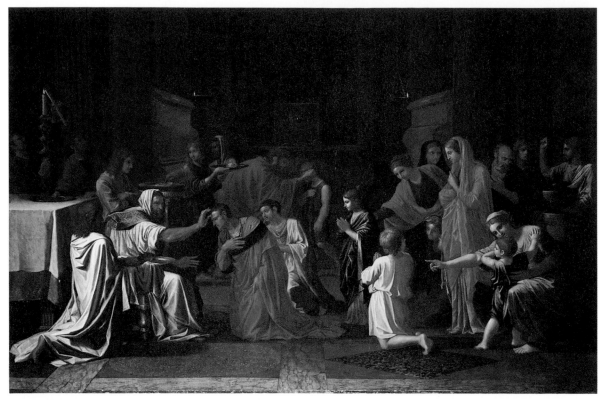

22. Poussin: Sacrament of Confirmation

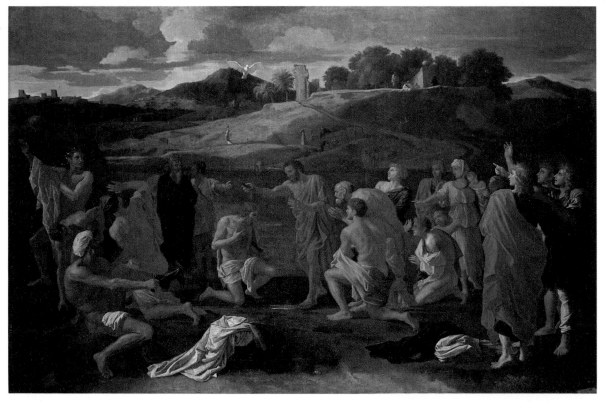

23. Poussin: Sacrament of Baptism

PISSARRO

Camille Pissarro (1830-1903) worked mainly in and near Paris. He became a prominent member of the impressionist group, and most of his pictures are impressionist in style. It was from Pissarro that Cézanne received the crucial part of his artistic training.

The Marne at Chennevières

It was painted in 1864/5, and probably exhibited in 1865. It is the most impressive of his few paintings that survived from before the Franco-Prussian war of 1870. The picture, which was worked out in the studio, reveals the extent of Pissarro's debt to the realism of Courbet, in the uncompromisingly sharp changes in tone between sky, land and river, and the rich use of pigment.

Kitchen Garden at the Hermitage, Pontoise *previous page 21*

This is a classic impressionist work of 1874. In contrast to the broad areas of pigment in the earlier landscape the paint is here applied in short even strokes. The palette has been transformed and the sombre colours of the Marne landscape replaced by an exquisite range of light greens, yellows and ochres.

PITTONI

G. B. Pittoni (1687-1767) was a contemporary of Tiepolo in Venice who followed, in the 18th-century idiom, the tradition of large-scale altarpieces and decorative paintings originated by Veronese.

Altarpiece with the Apotheosis of St. Jerome

It shows St. Peter of Alcantara in the foreground, a Franciscan who worked with St. Teresa of Avila in Spain in the early 16th century. It was painted in 1733 or shortly before. The attitudes of the figures create a lively, free-moving pattern in the space they occupy. But the picture has the common failing of rococo designs. The extravagant gestures are not backed by a corresponding urgency of feeling in the painter, so that they tend to remain theatrical, a triumph only of style. The altarpiece was one of four introduced into the church of S. Maria dei Miracoli in Venice, which became very popular and overcrowded in the 18th century.

POUSSIN

Nicolas Poussin (1593/4-1665), one of the most outstanding French painters, was born in France, but he settled in Rome in 1624 and remained there virtually for the rest of his life. Although his painting is profoundly French in spirit, he drew his inspiration from the Italian tradition, at first from Titian's Bacchanals and later from Raphael and ancient Roman carving.

The Mystic Marriage of St. Catherine

This is unlike most of Poussin's works, because it is painted on wood, because it is so big, and because the figures are so large in relation to the frame. There are, too, certain weaknesses in the design which are partly the result of changes made in the course of painting. The general effect is spirited, almost flamboyant, of a kind we do not normally associate with Poussin. However, the picture was in the collection of Cassiano dal Pozzo, Poussin's chief patron in Rome, and it is clear that it is one of the important works that have survived from his first years as a young man in Rome, about which we still know comparatively little.

The Seven Sacraments *opposite 22, 23*

Poussin had painted an earlier series of the 'Seven Sacraments' for the enthusiastic student of antiquity and friend of artists in Rome, Cassiano dal Pozzo, the last one being delivered in the summer of 1642. Five of these now belong to the Duke of Rutland. The second series, exhibited here, was commissioned by Fréart de Chantelou, a civil servant and secretary to Sublet des Noyers in Paris, and among the first Frenchmen to appreciate Poussin. Chantelou had originally asked for copies of dal Pozzo's 'Sacraments', but this proved difficult to arrange, and by March 1644 Poussin had undertaken to paint a new series. He began work on the *Extreme Unction* almost at once, and the seven pictures remained his principal concern until they were finished in March, 1648. It was in Chantelou's house that Poussin's great contemporary Bernini saw the *Sacraments* on his visit to Paris, a few months before Poussin died. After examining them closely he said: "You have to-day made me profoundly dissatisfied with myself, by showing me the power of a man beside whom I am nothing."
The impressive solemnity of these designs, in which the groups of statuesque figures are often arranged to form a long, shallow frieze, was inspired by Poussin's study of Raphael's designs in the Vatican and of ancient Roman relief-carving. Each picture is constructed on a central axis, most of them within a rigidly symmetrical setting. Poussin followed his usual procedure of making preliminary drawings of the compositions and reconstructing the scenes with wax models on a small stage in which he could control the lighting. The precise definition of figures and objects was worked out on the canvas itself. Of the corrections made at a fairly advanced stage, the most revealing is in the *Ordination*, where the tall pillar and the building with the pyramidal roof, and probably the bridge and buildings in between, were added in order to give emphasis to the grouping of the apostles and to the space behind them.
The pictures were painted on a reddish-brown (bolus) ground. Wherever the colours were not supported by solid white pigment over this ground, they have tended, in becoming more transparent with age, to allow the dark ground to show through them. This uneven darkening has to some extent upset the original balance of the colours. (Duke of Sutherland loan)

Moses Striking Water from the Rock

Poussin painted a number of different variations on this subject, of which this seems to be the earliest. It was painted about 1635/7, at the time when Poussin was turning his attention to the later works of Raphael. Individually the figures portray gratitude, relief, wonder and eagerness by turns. Their arrangement in coherent lines, crossing each other and receding into the depth of the picture, provokes at first glance by its agitation the mood of the subject. The contrast between this and the mood of the *Sacraments* reveals the importance Poussin attached to the sympathy between subject-matter and formal composition. (Duke of Sutherland loan)

PROCACCINI

G. C. Procaccini (1574-1625) was one of a strong school of artists who were working in Milan in the late 16th and early 17th centuries.

The Raising of the Cross

This is an altarpiece painted about 1620, to judge from its densely packed form of composition and its emphatic tonal design illuminated by intermittent accents of strong colour. Behind the cross is a Roman soldier on horseback, whose acrid crimson cloak makes a discordant accent close to Christ's head. To the right is the sorrowing Virgin, who is being urged away by a man who must be St John the Evangelist, whose face we do not see.

RAPHAEL
REMBRANDT
RENI
RENOIR

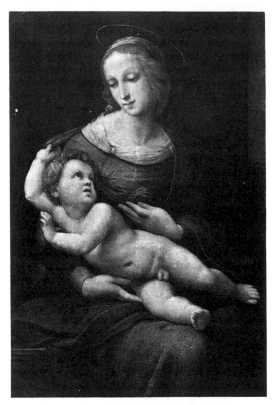

24. *Raphael: The Bridgewater Madonna*

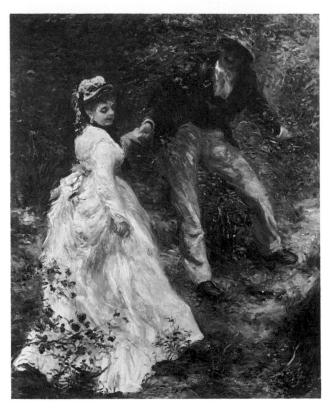

25. *Renoir: La Promenade*

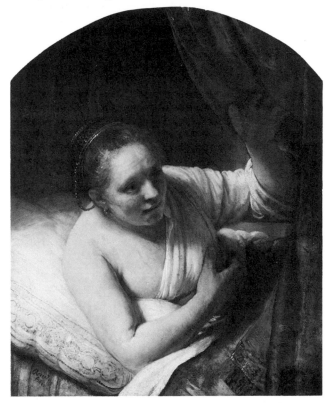

26. *Rembrandt: Woman in Bed*

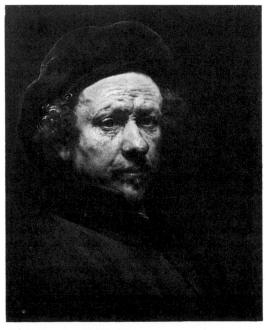

27. *Rembrandt: Self-Portrait*

RAPHAEL

Raphael (1483-1520) was born in Urbino. Towards 1500 he was assisting in Perugino's workshop. In 1504-1508 he was in Florence, where he was strongly affected by the work of Leonardo and Michelangelo. It was while he was in Florence that he painted most of his Madonna pictures. In 1508 he went to Rome, where he carried out his greatest work under Pope Julius II, the frescoes in the Vatican. In his last years under Pope Leo X, he acted as architect as well, and in effect as artistic overseer in Rome.

The Holy Family with a Palm Tree

It was painted in Florence about 1507. Raphael creates in his paintings an ideal world, as does Titian in *The Three Ages*. But colour, which was inseparable from Titian's images, is used here to embellish a design that is already complete without it. Raphael's painting is unemotional, a product of intellect and sensibility. The influence of Leonardo da Vinci is apparent both in the design of the figures and in the softness of the light. The composition has a symmetrical basis, and each departure from the symmetrical norm is balanced by an opposing movement. These things are perceived by the painter's intellect. He relies on sensibility to preserve at an even level the serenity of each part of the design: the gestures and expressions of the figures, and even the folds of drapery and the tranquil landscape behind.
(Duke of Sutherland loan)

The Bridgewater Madonna *opposite 24*

This picture dates from about 1508 and is among the last of Raphael's famous series of Madonnas painted before he left Florence. It is a masterpiece of international standing, unhappily fairly seriously damaged. The first impression of gentleness, almost of softness, is supported by the artist's clear and coherent sense of shape and by the sureness and precision of his drawing.
(Duke of Sutherland loan)

Madonna del Passeggio

Raphael had a considerable number of assistants working under him, executing his designs or variants of them. Several versions of this design are known, of which this is undoubtedly the best. When allowance is made for the blue of the Madonna's robe, which is now out of key because the pigment has changed with age, it is seen to be of considerable quality. It probably relies on a drawing by Raphael, but the painting itself is generally agreed to be the work of one of his assistants, possibly G. F. Penni.
(Duke of Sutherland loan)

REMBRANDT

Rembrandt van Rijn (1606-1669) was established in Amsterdam in 1631, and was for some time the most fashionable painter in Holland. In his mature work he used his sense of form and his appreciation of the effects of light and texture to create portraits and New Testament scenes which remain profoundly moving.

Woman in Bed *opposite 26*

This picture was probably painted about 1645 (the last figure of the date is missing). The woman used to be identified as Hendrickje Stoffels, but she is more likely to be Geertje Direx, who lived with Rembrandt after the death of his wife Saskia. In any case, the picture is not a portrait. The figure probably represents Sarah on her wedding night, watching anxiously as her bridegroom Tobias puts the devil to flight. It is not clear whether Rembrandt began with the intention of painting the single figure of Sarah as we now see it, or whether it originally formed part of a bigger picture.

Portrait of a Lady

It is dated 1634, the year in which Rembrandt, then twenty-eight, married Saskia and in the period when he had a large and growing practice as a portrait painter in Amsterdam. The portrait was painted on commission.
(Duke of Sutherland loan)

Hannah and Samuel in the Temple

This is a picture whose subject and author have been much discussed. It seems most likely that it represents the aged prophetess Hannah in the Temple, with a boy kneeling beside her, whilst Joseph and Mary are seen in the background with Simeon holding the Child Jesus in her arms. It has traditionally been attributed to Rembrandt, but the question is in doubt.
(Duke of Sutherland loan)

Self-Portrait *opposite 27*

Rembrandt's great series of self-portraits from different stages in his career is unparalleled in the history of painting. His understanding of texture, on which much of the power of his later work relied, was already apparent in the *Portrait of a Lady* of 1634, in the opposing qualities of the fuzzed out hair and warm transparent skin against the inert whiteness of the lace collar. But the dark line of the mouth and the edges of the lace are reminders of the painter's brush moving across the surface of the canvas. In this portrait, dated 1657, the form of the head and the qualities of flesh, hair and cloth are painted with a concentration that dissolves altogether our sense of the painted surface, and brings us on intimate terms with the man himself.
(Duke of Sutherland loan)

RENI

Guido Reni (1575-1642). His name has long been associated with a particular kind of sentimental religious picture, produced by his followers and imitators who gave him a bad name. His contemporary reputation as one of the most original Bolognese masters of the 17th century has today been restored.

The Infant Moses holding Pharaoh's Crown

The reassessment of Reni's art which has taken place in our day has encouraged a particular awareness of the beauty of the late pictures, of which the present one is a fine example. The style of these late pictures is characterised by a looseness and freedom in the handling of the paint which contrasts with the tightness in technique and high finish of the early pictures. The subject of the present picture has not altogether been satisfactorily explained, although it is possible that it illustrates the legend which tells of the occasion when the child Moses snatched Pharaoh's crown. In order to determine whether this action should be interpreted as an evil omen the child (here held by Pharaoh's daughter) was tested by being offered a bowl of gold and one of burning coals. He was saved by choosing the latter.

RENOIR

Pierre Auguste Renoir (1841-1919) began his career as a painter of porcelain in his native Limoges. His development followed that of the other impressionists until about 1880, when his style gradually changes.

La Promenade (The Walk) *opposite 25*

It is a masterpiece from the period when Renoir worked side by side with Monet, who greatly influenced him. Much of their time was spent out of doors where this picture was obviously painted; particularly effective is the rendering of the dappled effects of sunlight through foliage and the painting of the woman's white dress. This charming picture which breathes an air of domestic serenity was painted at a time when Renoir and Monet suffered hardship and penury.
(Anonymous loan)

REYNOLDS

Sir Joshua Reynolds (1723-1792) studied in Italy from 1750 to 1752. Settling in London in 1753 he soon became the leading painter in the new style, which combined portrait painting with the 'grand manner' of the Italian tradition. Against Gainsborough's fluency and sensibility he pitted scholarly design and careful finish. He was made President of the Royal Academy when it was founded in 1768.

The Ladies Waldegrave

The sitters were the daughters of James, the 2nd Earl: Lady Laura (aged 21) in the centre, Lady Maria (aged 20) and Lady Horatia (aged 19) working at a tambour. The picture was painted for Horace Walpole, their great-uncle, who paid Reynolds 300 guineas for it. It was exhibited at the Royal Academy in 1781.

RUBENS

Sir Peter Paul Rubens (1577-1640) was not only one of the greatest painters of the 17th century but also one of the most remarkable men in Europe of his time. His period in Italy (1600/08) was crucial to his development. His vast output ranged from large-scale decorations to designs for book illustrations. His genius was many-sided. He was a diplomat of distinction, a scholar and antiquarian, a fine linguist whose chosen language as a letter-writer was Italian. In Rubens many traditions combine and come together: the Christian and the Classical, the idealism of Italian art and the realism of the north.

The Adoration of the Shepherds

This is a fairly early work, painted in 1617 or before. Its size, and the lack of detailed finish, suggests that it was a *modello* or design for a larger work, but no such work has been traced. There are several reasons for thinking that Rubens may not have had any particular commission in mind when he painted this panel, although he later adapted its design to several altarpieces. A piece about six inches wide, which showed an old man and woman entering the stable with a candle, has at some time been cut from the right-hand side. The painting is unusual for Rubens, partly for the clear sense of an interior space, almost like a scene in a theatre, with the grotesque shadows cast on the floor and wall from the supernatural light shed by the Child, and partly for the sense of holy awe that hangs in the air, over the Virgin who was "troubled at Gabriel's word" and the shepherds who "feared exceedingly".

Head of St. Ambrose

It was painted a little later than the *Adoration*, about 1618. It is clearly a direct study from a model posed in the studio, and it was afterwards used in a figure of the bishop saint Ambrose.

The Reconciliation of Jacob and Esau
opposite 28

This is essentially a coloured drawing in oil paint, the kind of sketch Rubens would have done to show a patron what the work he had commissioned would look like. The present example is a design of about 1625 for a large canvas now at Munich in which studio assistants probably participated. The relationship between the two brothers in the sketch is perfectly stated: the magnanimity of Esau (the "cunning hunter, a man of the field") is contrasted with the subservience of the wily Jacob who had deceived their father into bestowing his blessing on him rather than on Esau. The handling is brilliant and assured.

The Feast of Herod

In designing large pictures and in the use of oil paint, Rubens' main debt was to the Venetian 16th-century painters. In this picture, painted about 1633-38, the setting of an open arcade, the negro bearing fruit and the boy with the monkey are echoes of Veronese's sumptuous banqueting scenes. The unflinching realism is Flemish. The painting was evidently begun by studio assistants but worked over by Rubens himself. The quality of almost everything, except minor accessories like the sword and the lobster, suggests this. (The bleached look of the woman's face is an old effect of overcleaning.) An extra strip of canvas at the left (the seam runs through the loaf of bread and the negro's right eye) is known to have been added, and the whole design to the left of Salome presumably had to be reorganised. This new group is a masterly piece of design and execution. The two servants with dishes and the man in front of them repeat the rhythm and spacing of the two arches and the columns between. The two men at the table and the boy in front form a third variant of the same grouping. The whole sequence is a subtle baroque expansion of an underlying classical symmetry.

RUISDAEL

Jacob van Ruisdael (1628/9-1682) worked until about 1656/7 in Haarlem, and thereafter in Amsterdam. He was one of the leading Dutch landscape painters in the third quarter of the century, who painted in fuller, richer colours than van Goyen and the preceding generation.

The Banks of a River

This picture was painted in 1649. (The foreground figures were painted in by another artist, a fairly common practice in Holland, where many painters specialised in one form of subject-matter.) Although the painter did not at this date do more than make drawings outside his studio, the distinctive theme of this painting, the river-bank with its arabesque of paths, preserves the clarity and boldness of a statement made from direct observation. Ruisdael had already painted it in a smaller and simpler picture dated 1647 (now in Nivaagaard near Copenhagen). Here the theme is elaborated by the sympathetic formation of clouds above the bank, and by the trees closing the design at the left.
(Sir James Erskine of Torrie Bequest, on loan from the University)

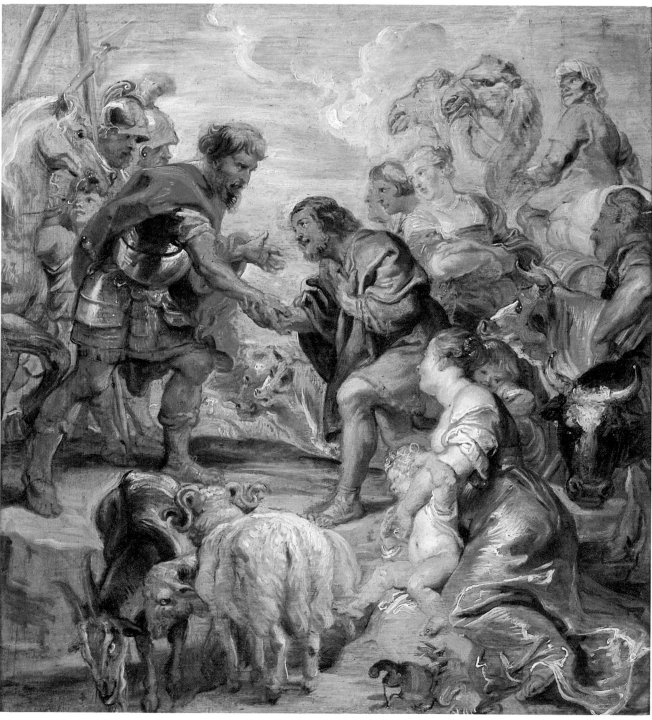

28. Rubens: The Reconciliation of Jacob and Esau

SAENREDAM
SARTO
SEURAT
STEEN
TERBORG

29. Saenredam: Interior of St Bavo's Church, Haarlem

SAENREDAM

Pieter Saenredam (1597-1665) was the greatest of the Dutch architectural painters. His pictures, which are faithful representations of actual buildings, break with an older more fanciful tradition of treating architecture which involved high viewpoints and exaggerated perspective effects. Saenredam spent most of his life in Haarlem with occasional visits to other parts of Holland to record buildings, mostly churches.

Interior of St Bavo's Church, called the "Grote Kerk", Haarlem *opposite 29*

This picture, signed and dated 1648, was in the Royal Collection until the 18th century, a gift to Charles II, and is possibly the artist's masterpiece. It is based on carefully prepared drawings made some 15 years earlier but transcends mere recording of actuality. The sense of place and the grandeur of it are marvellously evoked through a very sophisticated use of perspective and subtle treatment of light. The silence of this great interior is undisturbed by the presence of human beings (who are either absent or play a subsidiary role in Saenredam's pictures). And such is the power of this mood that the picture demands a certain silence on the part of the spectator too.

SARTO

Andrea del Sarto (1486-1530) was the most influential painter in Florence at the time when Raphael was working in Rome.

Self-Portrait

It was painted near the end of his life and is a brilliant example of Italian High Renaissance portraiture. In an image that seems deceptively simple, Sarto reconciles the opposing elements of the individual form and the ideal, of outward appearance and inner character, and of the living, moving man and the flatness and fixity of the painted surface. The pose, modelling and colouring of the figure, its relationship to the frame of the picture and to ourselves as spectators, all contribute to the sturdy, self-assured impression we receive of the man's personality.

SEURAT

Georges Seurat (1859-1891) trained as a draughtsman in the academic tradition of Ingres. He made a very considerable contribution to post-impressionist painting in the eight years before his early death.

Study for 'Une Baignade'

This was painted at Asnières outside Paris in 1883. It is one of a series of studies which led up to Seurat's first large picture, now in the National Gallery, London. The division of greys into their component hues touches the factory chimneys of Courbevoie with the tenderness of a Renoir. But Seurat's contribution was in imposing on the impressionist vision classical severity of structure, and in this study we see part of the process at work. The boy watering his pony still retains in his crisp silhouette the tension that sprang from Seurat's first encounter with the sight. But the boy on the bank, who had already appeared in earlier studies, has surrendered his personality to the scene and has become a part of its essence.

La Luzerne, Saint-Denis

This picture was painted between the completion of 'La Baignade' and Seurat's second major figure composition 'La Grande Jatte' (1886). Despite the increased development and refinement in the painter's application of his principles of colour division, *La Luzerne* is still not what is usually termed a "pointillist" composition. It is chiefly painted in short diagonal strokes nicely gauged to reproduce the scale of poppy-heads and lucerne stalks at a certain distance from the eye, so that the gradual diminution of these brushmarks towards the horizon is sufficient to establish the viewer's exact angle of vision across the receding expanse. The subject was probably chosen for the dynamic contrast set up between red and green, which is echoed throughout by the painter's subtler exploitation of the other two complementary pairs, yellow/violent, and blue/orange, so that the whole surface of the canvas appears to vibrate with colour.

STEEN

Jan Steen (*c.* 1626-1679) specialised in painting humorous and sometimes moralising scenes of the life of the people, which are very often crowded and full of incident. He worked at different times at Leyden, Delft, Haarlem and The Hague.

The Schoolroom

This picture is a characteristic product of Steen's exuberant invention with its Dickensian accumulation of incident. It is probably a moral lesson on the results of negligence. The owl at the right illustrates a Dutch proverb: "What use are candle and spectacles, if the owl does not want to see". The colour scheme is based on artful variations of powder blue, mauve and dull red brick.
(Duke of Sutherland loan)

TERBORG

Gerard Terborg (1617-1681) painted cabinet-sized portraits based at first on Hals and Rembrandt, and interior scenes in which he shows an urbane delicacy of drawing and colouring and a keen sense of the texture of materials.

A Singing Practice

This is a version of a painting of before 1655, in the Rijksmuseum. Terborg's contemporary in France, Molière, also used the situation of the young man who poses as the music master to gain an interview with his beloved under the more or less watchful eye of the chaperone.
(Duke of Sutherland loan)

TIEPOLO

G. B. Tiepolo (1696-1770) was the outstanding painter in the same tradition as Pittoni, whose work he influenced considerably. Most of his major works were painted in fresco on the walls and ceilings of buildings in Venice and Würzburg.

The Finding of Moses

This is the most important of Tiepolo's paintings in Britain. The main group of figures occupied originally the left-hand half of the composition. A piece 1.33 metres wide, containing at the extreme outer edge the standing figure of a halberdier, was at some time cut off from the right-hand side, and is now in a private collection. The Princess of Egypt stands in what is now the centre with her duenna, a page and a court dwarf. Miriam comes in from the left. Tiepolo makes the scene into a brilliant decorative fantasy, deliberately evoking a romantic vision of the golden age of Venice. The costumes are Venetian of the 16th century, and the landscape, except for the palm trees, is hardly intended to appear Egyptian. Tiepolo based the figures and their general arrangement on a painting by Veronese (Dresden Gallery), which was in Venice until 1747. Tiepolo probably painted our picture in the latter 1730s.

The Meeting of Anthony and Cleopatra

This is a sketch for a centre-piece in the fresco decorations of the Palazzo Labia, Venice. The rest of the frescoed wall is filled with a realistically painted architectural setting, so that it seems as though the life-size figures of Anthony and Cleopatra are on the other side of an archway and are about to descend the (painted) marble steps into the room itself.

TINTORETTO

Jacopo Robusti (1518-94), known as Tintoretto, worked in Venice as an independent artist from 1539. He formed his very personal and unusually forceful style principally from the study of Titian and Michelangelo. His best known work is the monumental cycle of New Testament scenes in the Scuola di San Rocco, Venice.

The Descent from the Cross

It was probably painted in the 1560s, and comes from an alterpiece in the Venetian church of San Francesco della Vigna. The painting originally had a semi-circular top, adding about 25 cm to the height at the centre and showing, above the body of Christ, the foreshortened figure of an angel bearing the crown of thorns. What survives was cut out from the altarpiece, evidently some time before the 1640s, and strips of canvas have been added on all four sides. Although the picture has darkened considerably, the high quality of design and drawing are still clearly in evidence. (Duke of Sutherland loan)

TITIAN

Tiziano Vecellio (?1485/8-1576) studied partly under Giovanni Bellini, and collaborated with Giorgione (about 1477-1510). He worked mainly in Venice, receiving many of his commissions from other parts of Italy and from Spain (he was made court painter to Charles V in 1533). In his later paintings he arrived at a flexibility of technique which revolutionised the whole tradition of painting in Europe.

The Three Ages of Man

This picture, painted about 1515, presents one of the favourite themes of the period. The mood is set by the poetic encounter between the young shepherd and his companion, and there is a silent communion between them and the neighbouring trees, from which the dotard mumbling over his skulls is excluded. It seems unlikely that Titian had in mind any subject as specific as the traditional title suggests. This kind of picture, in which the landscape and the figures inhabiting it convey an atmosphere rather than tell a story, is the beginning of the modern conception of painting. And it was the Venetian painters, the young Titian and Giorgione particularly, engrossed in the study of light and its effect upon form, colour and atmosphere, who conceived it. (Duke of Sutherland loan)

Venus Anadyomene

It dates from about 1520. Parts of the face, particularly the eyes, most of the hair falling over her shoulders and the contour of her left shoulder are later repaintings. In his book on 'The Nude', Lord Clark says: "In spite of this she remains one of the most complete and concentrated embodiments of Venus in post-antique art. If the pipe-player in [Giorgione's] 'Concert Champêtre' anticipates the shape of the female nude in the 19th century, [this] Venus anticipates the whole conception of the subject which ended, for our generation, in the nudes of Renoir; that is to say, the female body, with all its sensuous weight, is offered in isolation, as an end in itself." (Duke of Sutherland loan)

Diana and Actaeon *opposite 30*
Diana and Calisto

The first canvas shows Actaeon, whilst hunting, surprising Diana as she bathes. Calisto, one of Diana's companions, was seduced by Jupiter disguised as Diana herself, and the second canvas shows Calisto's disgrace revealed to Diana.

Titian painted a number of pictures for Philip II of Spain, whom he first met at Augsburg in 1550 when he painted his portrait. Some of these were of religious subjects and were expressly commissioned, others were mythological and their choice seems to have been left to Titian's discretion. The subject-matter of these canvases was well suited to Titian's pre-occupation with the problems of space and light and the subtleties of modelling in the human figure. They were despatched from Venice together with an 'Entombment' (now in Madrid) towards the end of 1559, when Titian was at least in his seventies. He had been working on them for over three years.

The serenity that pervaded the masterpieces of the High Renaissance, among them *The Three Ages of Man* and Raphael's *Holy Family with a Palm Tree*, was rapidly dissipated after the first quarter of the century in the sack of Rome and the confusion that followed. Titian's paintings became graver and more profound as he grew older. But the sense of tragedy presiding over them is a reflection, too, of the changing mood of the whole of Italy.

Roger Fry, citing the *Diana and Actaeon* as one of the earliest Baroque designs, compared it with the relatively flat, frieze-like design of the 'Bacchus and Ariadne' (now in the National Gallery, London), which Titian had painted thirty-five years before. Of the group of Diana and her companions which lead back into the picture, he wrote, a "diagonal plane is built up by a continuous long-drawn plastic phrase which has at once the most perfect rhythmical continuity and the most intriguing variety".

The *Diana and Calisto* has suffered more and, although parts of it are unusually expressive and clearly designed, the whole composition lacks the masterly coherence of its companion. Titian seems to have recognised this, and in a later version of the picture (now in Vienna), apparently begun as a replica, he made severe alterations to improve the composition. (Duke of Sutherland loan)

30. Titian: Diana and Actaeon

31. Vermeer: *Christ in the House of Mary and Martha*

TURNER

J. M. W. Turner (1775-1851) was a strangely unsociable person and the undeniable master of British landscape painting. He began by modelling himself closely on the work of Claude. His later, almost visionary style grew out of the marriage between this study and his direct observation of landscape and atmospheric effect.

Somer Hill, near Tonbridge

This is in fact one of the great number of topographical views that were produced around the turn of the 18th and 19th centuries. The country gentleman, after having a "landscape" setting laid out round his country house, with rolling lawns and ingeniously placed trees, created a demand for artists to put his improvements on record. Turner performed many of these commissions, and he painted his view of Somer Hill in 1810. It reveals the power of Turner, so often a spectacular painter, to create a complete sensation of space and light in a quiet and restricted range of colour.

Rome from Mount Aventine

Exhibited at the Royal Academy in 1836. It was probably based on studies made when the artist was in Rome in 1828/9. Unlike *Modern Rome–Campo Vaccino* (see below) it does not seem to have had any intended symbolic significance, and Turner is said to have been commissioned to produce a 'copy' –i.e. a true likeness–rather than an idealised scene. Both this and *Modern Rome* are beautiful examples of Turner's later style, and of his command over a complex high level perspective as well as the structural details of various masses of buildings only half discernible through a shimmering opalescent light.
(Earl of Rosebery loan)

Modern Rome–Campo Vaccino

Exhibited at the Royal Academy in 1839. The title indicates the date at which the spectator is supposed to be looking at Rome, not the age of any buildings that appear in the picture, for these are remnants of Rome from several earlier periods and include the ruins of the Coliseum in the central distance. The subject was paired in the 1839 exhibition with another painting now in the Tate Gallery, *Ancient Rome: Agrippina landing with the ashes of Germanicus.* This composition, set in the first century AD, is also an evening picture, but shows the classical buildings still intact and unruined. The decline of empires was a subject that held great fascination for Turner and was endowed by him with private symbolic meaning. He liked to pair his

pictures, and had already treated the contrast between ancient and modern Italy in a couple of pictures exhibited the previous year.
(Earl of Rosebery loan)

VELAZQUEZ

Velazquez (1599-1660) settled in Madrid in 1623 as court painter to Philip IV, where his chief business was portraiture. Rubens met him when he visited Madrid in 1628-29, and it was on his recommendation that Velazquez was sent on his first visit to Italy in 1629-31. The fluent handling and transparent colour, which he developed after this time, have little connection at first sight with the work he did before he went to Madrid.

An Old Woman Cooking Eggs *front cover*

Clear traces of the date, 1618, were discovered not long ago in cleaning. Velazquez finished his five years' apprenticeship in that year, and opened a studio of his own in Seville. By then he was already seeing his subjects in terms of strong light and shade, which he must have learned from followers of Caravaggio. (He would certainly have seen pictues akin to the *St. Christopher,* painted in Rome some time after 1604 by Orazio Borgianni (*c.* 1578-1616). Borgianni had connexions with Spain, and he sold another version of this design to the Spanish ambassador in Rome.) Paintings of kitchen-scenes, which had then recently become popular in Seville, seem to have been inspired by engravings from Flemish pictures of the previous century. But although style and subject were borrowed from abroad, Velazquez worked out his picture in his own studio, with two Andalusian peasants posing in front of him. They, and the several vessels on the table, appear again in other pictures that he painted at this time. The deliberation with which figures and objects are related in this picture is at once apparent in the calculated meeting of the two hands above the dish of eggs. The colours, too, form a coherent series of whites, yellows and browns against the dark background. The strange sense of aloofness in the two figures suggests, perhaps, the degree of concentration with which the young Velazquez applied himself to each part of the subject in turn.

VERMEER

Jan Vermeer (1632-1675) lived and worked in Delft. The paintings of his developed style are on a small scale, and usually represent tranquil domestic interiors.

Christ in the House of Mary and Martha
opposite 31

This picture was not recognised as by Vermeer until cleaning revealed the signature early in this century, shortly after the picture had been sold in Bristol for £8. It was painted about 1654 and is probably the earliest of his known pictures. In his mature work the whole of the room that he paints is informed with a precise sense of interval between one object and the next, a formal coherence that is here comparatively weak. At this stage Vermeer was working in a style, deriving ultimately from Caravaggio, which he must have learned from the pictures of Terbrugghen and the Caravaggesque painters in Utrecht. The study of strong local colours seen under a direct light was for him a more valuable training than this form of composition. Martha is shown leaning over the table as Christ speaks to her, pointing to Mary sitting opposite to Him. In his later work Vermeer avoided such incidents in the course of a narrative, in his desire to exclude the sense of time and movement from his pictures.

VERROCCHIO

Andrea Verrocchio (*c.* 1435-1488) was one of the leading artists working in Florence in the early 1470s, when this picture was probably painted. He worked as sculptor and silver-smith as well as painter, and he shared with his contemporaries (Leonardo da Vinci was one of his pupils), the passionate curiosity about the real world that we associate with the Renaissance.

Madonna and Child *opposite 32*

It is distinguished for its brilliantly clear and simple design. The image of the Madonna herself is one of gentleness–Bernard Berenson said of it: "she cannot be merely human, she must be divine". The drawing of the pavement and the building behind has the precision of a geometrical figure–if you look closely, you can see the construction lines of the floor were drawn in with a ruler and run underneath the blue of the Madonna's robe. The architecture evidently represents the ruins of a classical building, but it is not clear what it could have been like originally. We do not, in fact, imagine for a moment that we are looking at a scene in real life, yet the picture celebrates some of the delight of real life–the spirit of human tenderness in the Madonna, and a sense of air and space in the soft, cool brightness that floods over the pavement and over the beautiful view of Tuscan hills that we glimpse through the archway. And the painter's sense of wonder at it all still reaches us across the five hundred years since he painted it.

VUILLARD

Edouard Vuillard (1868-1940) spent most of his life in Paris. With his friend Bonnard he was one of the Nabis (from Hebrew, Prophets), an artistic fraternity whose members were greatly influenced by Gauguin.

The Candlestick *opposite 34*

Painted about 1902, it is the finest of a small group of pictures by Vuillard. The uneasy relationship between the eloquent voids and busy patterned areas is held in brilliant equilibrium. The impression of flatness which the artist was at pains to stress is a reminder of the famous saying by Maurice Denis, a friend of Vuillard's: "Remember that before it is a warhorse, a naked woman, or a trumpery anecdote, a painting is essentially a flat surface covered with colours assembled in a certain order."

WATTEAU

Antoine Watteau (1684-1721) spent most of his short life working in Paris. He learned most from the work of Rubens and Veronese, distilling from this robust mixture his own subtle and imaginative style. J.-B. Pater, one of his most successful followers, is also represented here.

Fêtes Vénitiennes *opposite 33*

This is one of his finest pictures. It was painted about 1718-19, and has survived in unusually good condition. The scene, which is made to appear almost as though it took place on an operatic stage, is set in an orna-mental park laid out in the manner then fashionable in and around Paris. The dancer in Oriental dress is Vleughels, with whom Watteau was lodging at the time, and who was the Director of the French Academy in Rome when the Scottish painter Allan Ramsay was studying there in 1736. Several of the other figures recur in other paintings, like the man playing the musette, who appears again in a picture now in Potsdam, but with a different head and looking the other way. These recurrences are common in Watteau's work, since he drew freely on his sketchbooks when composing his pictures. Alterations which have now become visible show the extent to which he was prepared to alter his design at an advanced stage. Heads have been painted out to the right of the musette player and to the left of the woman's profile head at the left, the lady dancing has had the hem of her skirt raised, and Vleughels was painted over a different dancer, whose legs show through behind.

ZURBARÁN

Francisco de Zurbarán (1598-1664) began his artistic training in Seville at about the same time as Velazquez. The two painters knew each other early on and remained life-long friends. Zurbarán worked in Seville most of his life. Nearly all his paintings are of religious subjects.

The Immaculate Conception

This shows the young Virgin with St. Joachim and St. Anne in adoration. The subject was a favourite one in Seville, and both Zurbarán and, in the next generation, Murillo were called on to paint it a number of times. This dates from about 1640. It was evidently designed for a position above eye-level, possibly for a Carthusian monastery in Jerez. The light, clear pink, blue and yellow of the upper part of the painting are contrasted by the heavier, earthier colours, olive green, purple brown, and brick red, in the clothes of the Virgin's parents, Joachim and Anne. Originally these two figures were almost certainly shown full length, so the canvas must have been cut down at some time.

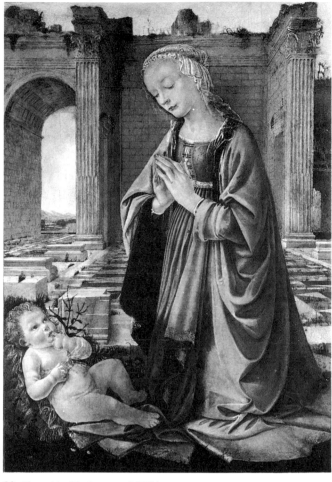

32. Verrocchio: Madonna and Child

33. Watteau: Fêtes Vénitiennes

34. Vuillard: The Candlestick

35

Raeburn: Rev. Robert Walker skating on Duddingston Loch.

ALLAN
DRUMMOND
DYCE
GEDDES
GUTHRIE
HAMILTON

35. Dyce: Christ as the Man of Sorrows

36. Guthrie: The Hind's Daughter

ALLAN

David Allan (1744-1796) was apprenticed to the Foulis Academy in Glasgow. In 1764-77 he was in Rome, where he studied under Gavin Hamilton (q.v.). Allan was in London 1777-80, and from then on in Edinburgh. In 1786 he succeeded Alexander Runciman as Master of the Trustees' Academy. Besides portraits and conversation pieces, he produced water-colours and etchings of scenes of Scottish life, which are the liveliest of his works and began the tradition of genre-painting in Scotland.

The Origin of Painting

It dates from 1775, while Allan was still in Rome. The subject, which was popular in the 18th century, is taken from Pliny.

Sir John Halkett of Pitfirrane Bart (1720-93), his Wife and Family

It was painted in 1781. On returning to Scotland, Allan supported himself by painting family groups, a type of picture halfway between conventional portraiture and the imaginative figure compositions he would have preferred. "I am glad at least," he said of his patrons, "that they have got into the notion their familys done in familiar case in Groups, by which painters may get great improvemen in this study of Nature." There is a key to the sitters' identities on the back. Allan noticeably took most trouble over Sir John's portrait and became lazy in those of the babies and dog.

ALLAN

Sir William Allan (1782-1850) painter of Oriental scenes and Scottish history. Trained in Edinburgh at the same time as Wilkie. Travelled in Russia, 1805-13, and in Italy and Constantinople 1829-30. Master of the Trustees' Academy, Edinburgh 1826-44, and President of the RSA from 1837.

The Slave Market Constantinople

This picture was painted in 1838. In the centre a Turkish Pasha is shown buying a Greek girl from a black Egyptian slave merchant. Allan told a friend that he had seen all the incidents "on the spot". The strong light and brilliant colour of Constantinople stimulated Allan to discard his usual murky brown colouration for a more natural 'daylight' effect.

DRUMMOND

James Drummond (1816-1877) was born in Edinburgh and studied at the Trustees' Academy under William Allan. He was curator of this Gallery from 1868.

The Porteous Mob

It was painted in 1855. Like his contemporary, Noel Paton, Drummond was notable for his highly detailed and finished style, and his antiquarian interests. The scene shown here is the lynching of Captain Porteous by an enraged mob of Edinburgh citizens in 1737, as described by Sir Walter Scott in his novel *The Heart of Midlothian*. Drummond, who had a profound knowledge of the closes and buildings of ancient Edinburgh, has used the story as an opportunity to reconstruct the likely appearance of the Grassmarket in the mid eighteenth century.

DYCE

William Dyce (1806-1864) studied art in Edinburgh and London. In 1827-29 he was in Rome where, like David Scott, he was in contact with the 'Nazarene' painters. Some of his pictures of the early 1840s foreshadow the style of the Pre-Raphaelites.

Francesca da Rimini

First exhibited in 1837 it illustrates an episode in Dante's *Inferno*. The figure of Francesca's husband Gianciotto discovering his wife kissing his brother Paolo, which originally appeared on the left side of the canvas, was cut away in 1881, and only Gianciotto's hand remains. Dyce at this stage was working with clear bright colours and well-defined outlines in a style influenced by 15th-century Italian painting, and close also to that of the Nazarenes, especially Overbeck.

David in the Wilderness and Christ as the Man of Sorrows *opposite 35*

They were probably painted as a contrasting Old and New Testament pair of subjects about 1860. The example of the Pre-Raphaelites inspired Dyce with an interest in accurately detailed landscape and he here experimented with the idea of placing biblical figures against a background painted from Scottish Highland scenery. Perhaps he thought the shock effect of this would bring the stories home to the viewer in a special way, but whatever his intention he succeeded in creating a very intense and moving pair of religious landscapes.

GEDDES

Andrew Geddes (1783-1844) was born in Edinburgh. In 1806 he went to London to study at the Academy schools. He was there at the same time as Wilkie, with whom he formed a lasting friendship. He worked mainly as a portrait painter, in Edinburgh 1810-14 and thereafter in London, making frequent visits to Scotland.

The Artist's Mother

Geddes' style is variable and uneven. Some of his portraits, and often the least successful, are in a style that might be expected of a man who began when Lawrence and Raeburn were well established. But Geddes also made numerous copies from old masters, and some of his best pictures are deliberate pastiches. The lighting of this portrait and the way the face is painted were inspired by Rembrandt. It was painted probably in 1813.

Summer

Exhibited in 1828, it is based on Rubens' 'Chapeau de Paille' (National Gallery, London), of which Geddes had made studies. The model is Charlotte, Alexander Nasmyth's youngest daughter.

GUTHRIE

Sir James Guthrie (1859-1930) was born at Greenock and studied art in London and Paris. He was a leading member of the 'Glasgow School' group of painters during the 1880s.

The Hind's Daughter *opposite 36*

A hind is a farm labourer. This picture was painted in 1883 at the village of Cockburns-path near Dunbar where many of the Glasgow School painters had gathered to work with Guthrie. The influence of the French realist Bastien-Lepage is clearly apparent in the colour and design, but Guthrie's brushwork is far bolder than that of Lepage.

HAMILTON

Gavin Hamilton (1723-1798) was born in Lanark and attended Glasgow University. In the 1740s he studied under Masucci in Rome where, apart from visits to Britain, he spent the rest of his life. After practising as a portraitist he turned to the painting of large scenes from ancient Greek and Roman myth and history, and combined his painting career with the business of exporting antique statues which he had excavated at various classical sites.

Achilles lamenting the Death of Patroclus

This was painted at Rome in 1763, the second in a series of six pictures illustrating Homer's poem the *Iliad*. Hamilton's use of an austere sculptural style to evoke the mood of ancient Greece had a profound influence on the subsequent neo-classical movement, especially on the work of J.-L. David, the leading French exponent of this style.

ALLAN
DRUMMOND
DYCE
GEDDES
GUTHRIE
HAMILTON

HARVEY

Sir George Harvey (1806-1876) came to Edinburgh in 1823 and studied at the Trustees' Academy. He took an active interest in the formation of the Scottish Academy in 1826. He is best known for his series of Covenanting pictures. *The Curlers* is a study for the larger painting exhibited in 1835.

HORNEL

Edward Atkinson Hornel (1864-1933) though born in Australia and trained in Antwerp is counted as a Scottish artist because of his close involvement with the Glasgow School movement. Like George Henry, with whom he visited Japan in 1893, Hornel was concerned with a more decorative, colourful, and less realistic form of painting than Guthrie.

Music of the Woods *opposite 37*

This picture was painted in 1906 and is a typical example of Hornel's tapestry-like use of plants and flowers as a setting for a group of children. He liked to evoke a lyrical atmosphere but was uninterested in specific, story-telling subject matter.

JAMESONE

George Jamesone (*c.* 1590-1644) was born in Aberdeen and was apprenticed to a decorative painter in Edinburgh. Until 1633 he worked as a portraitist in Aberdeen, and subsequently extended his practice to Edinburgh as well.

Lady Mary Erskine, Countess Marischal

This portrait was painted in 1626 when the sitter was twenty-nine years old. She was daughter to the Earl of Mar and wife of the sixth Earl Marischal whose father founded Marischal College, Aberdeen. This portrait is the oldest painting by any Scottish artist in the Gallery's collection.

LAUDER

Robert Scott Lauder (1802-1869) studied at the Trustees' Academy. After three years in London, he returned to Edinburgh in 1826. In 1833-38 he was studying in Italy. From 1838 he was in London, where he became known for his illustrations of Walter Scott and the Bible. In 1852-61 he was in Edinburgh as Master of the Trustees' Academy, where his gifts as a teacher had a considerable influence over Scottish painting. *Henry Lauder* is a portrait of his younger brother, who died in 1827 at the age of 20.

LORIMER

John Henry Lorimer (1856-1936) was born in Edinburgh, studied at the RA Schools, London, and under Carolus Duran in Paris. He was the brother of the architect Robert Lorimer.

The Ordination of Elders in a Scottish Kirk

This was painted in 1891. It is an imaginary scene. The Kirk was made up out of interior views of several buildings, and the models who posed were tradesmen of various kinds –none of whom were actually Elders! From Carolus Duran Lorimer would have learnt the knack of bringing the viewer almost inside the picture instead of distancing him as Wilkie had done in *Distraining for Rent* Realistic scenes of everyday life amongst ordinary Scots folk were often preferred in the late nineteenth century to the kind of romantic subjects William Allan, Drummond, and Paton had painted.

McCULLOCH

Horatio McCulloch (1805-1867) was born in Glasgow and studied landscape painting under John Knox. He was acclaimed by contemporaries as the national artist who had succeeded in expressing, better than anyone else, the true spirit of Scottish scenery.

Inverlochy Castle *opposite 38*

It shows the castle on the River Lochy at the foot of Ben Nevis. McCulloch painted this view in 1857 from a sketch made on the spot in the previous summer. A group of cattle which originally appeared on the shore was painted out by the artist, and the dinghy substituted after the picture was first exhibited.

MACGREGOR

W. Y. Macgregor (1855-1923) studied at the Slade School in London under Alphonse Legros. His studio formed the meeting-place for the members of the Glasgow school in the early 1880s. Most of his work is in landscape.

The Vegetable Stall

This is a comparatively early work, dated 1884. Macgregor's teacher, Alphonse Legros, taught that there was a severe beauty of design, the enemy of sentimentality, which the painter must learn to extract from reality. For the subject of this picture, the master-work of his early years, Macgregor chose vegetables, because it is easier to look at a turnip with a dispassionate, than with a sentimental eye. The low key, in which this and the Glasgow landscapes are painted, is common ground with Walter Sickert, another pupil of Legros and admirer of Whistler, and the New English Art Club.

MACNEE

Sir Daniel Macnee (1806-1882) was brought up in Glasgow. He worked in Edinburgh for a time under the engraver W. H. Lizars, and studied at the Trustees' Academy. In 1830 he returned to Glasgow where he established himself as a portrait painter. *The Lady in Grey,* dated 1859, is a portrait of his daughter. The composition is based on Reynolds' 'Nelly O'Brien' (Wallace Collection, London).

McTAGGART

William McTaggart (1835-1910) studied at the Trustees' Academy 1852-59 under Lauder (see above). He visited Paris as a student and on two short tours later on. Except for his *Self-portrait* of 1892, his best known pictures are landscapes painted in the Kintyre peninsula on the west coast.

Spring *opposite 39*

Dated 1864 it is characteristic of McTaggart's early style which was influenced by the colour and detail of the Pre-Raphaelite paintings he had seen exhibited in Manchester and Edinburgh.

The Young Fishers

McTaggart was a contemporary of the French impressionists, and his paintings of the 1870s are freer in handling and less artificial in effect than his work of the 1860s. But *The Young Fishers*, finished in 1876 when impressionism was at its height in Paris, shows how little he had in common with the comparatively objective study of optical effects of the impressionists. The picture relies on the image of the rowing-boat on the water, which is charming and authentic, but coloured by his feelings rather than by his apprehension of reflected light.

The Storm

This picture is dated 1890. Most of McTaggart's enthusiasm was reserved for the sea, and his knowledge of it was the outcome of a lifelong acquaintanceship. From the 1880s he developed an increasingly free and arbitrary technique in his attempt to express the effect of wind and the movement of spray and waves.

37. Hornel: Music of the Woods

38. McCulloch: Inverlochy Castle

39. McTaggart: Spring

NASMYTH

Alexander Nasmyth (1758-1840) was born in Edinburgh. He studied at the Trustees' Academy under Alexander Runciman, and by 1775 he was working in Allan Ramsay's studio in London. He settled in Edinburgh as a portrait painter in 1778, at much the same time as Raeburn. He also worked as landscape gardener and architect (the design of St. Bernard's Well, Stockbridge, is his) but his greatest contribution was as the father of Scottish landscape painting, as Wilkie described him.

ORCHARDSON

Sir William Quiller Orchardson (1832-1910) was born in Edinburgh and studied at the Trustees' Academy. In 1862 he moved to London where he developed a highly personal style of great elegance and delicacy. His characteristic Regency drawing room scenes were interspersed with portraits and a few renderings of contemporary life.

Master Baby *opposite 40*

It dates from 1886 and is a portrait of the artist's wife Ellen Moxon whom he married in 1873, and of his son Gordon. The grouping was based on a real incident observed by the artist and completed in a few weeks, entirely for his own pleasure. The painter Sickert, and George Moore, novelist and critic, both admired the picture extremely. The latter felt that it was full of the charm of English home life without being marred by any "vulgar sentimentality".

PATON

Sir Joseph Noel Paton (1821-1901) was born in Dunfermline and studied at the Royal Academy schools in London where he made friends with Millais, the Pre-Raphaelite painter. He was appointed Queen's Limner for Scotland in 1866.

The Quarrel of Oberon and Titania
opposite 41

It illustrates Shakespeare's play *A Midsummer Night's Dream* and was painted in 1849. It is one of the most detailed and highly worked of many Victorian paintings dealing with fairies. Paton was probably influenced by Fuseli's Shakespearian paintings with their contrasting figure scales from large to miniature.

PHILLIP

John Phillip (1817-1867) was born in Aberdeen and studied at the Royal Academy schools in London. His early pictures were genre scenes modelled on Wilkie's work, but after a visit to Spain in 1851 his brown colouring and rural Scottish subjects were abandoned, and most of his later pictures were scenes of Spanish peasant life, painted in brilliant tones of scarlet, pink and black.

La Gloria

Dated 1864, it was painted after Phillip's last visit to Spain, and represents a Spanish custom of celebrating a child's death in the belief that the infant's soul had gone direct to heaven. The painting is divided into two contrasted zones of light and darkness used chiefly for expressive effect. In the light zone are the dancers and musicians, while the bereft mother crouches in the shadow to the left and refuses to be comforted or join the dancers.

RAEBURN

Sir Henry Raeburn (1756-1823) was apprenticed to an Edinburgh jeweller in 1772, and began painting fairly soon afterwards. In 1784 he went to Rome, a journey said to have been urged on him by Reynolds when he saw the young man's work in London, but study in Italy made very little difference to his style. In 1787 he returned to Edinburgh, where he very soon established himself as the leading portrait-painter. He sent portraits irregularly to the Royal Academy in London, and was elected A.R.A. in 1812 and R.A. in 1815. But Edinburgh in the 1790s was a prosperous and expanding city, and Raeburn remained here. He was knighted by George IV on his visit to Scotland in 1822.

As Raeburn grew up, he had watched the 'draughty parallelogram' of the New Town of Edinburgh, whose first buildings were begun about 1770, growing up beside him. He set up in George Street in 1787, and by 1798 had built himself a studio in York Place. In the same house was an exhibition room, in which some of the early annual exhibitions of painters' work were held.

Raeburn's Portraits 1780-1800

Raeburn seems to have been largely self-taught. In painting his portraits he aimed always at the general effect of the picture, and his direct method of painting with broad sweeps of the brush was evolved to serve this end. If his drawing often lacks refinement for this reason, he nevertheless endows his sitters, even in his portraits of the 1780s, with solidity and a convincing presence. Up to about 1800 the colouring of his painting is comparatively light in tone, the lighting distributed evenly over the figure and background. Perhaps his most attractive portraits were painted in the 1790s. A few early double portraits are outstanding for their freshness of design, but are unfortunately not represented here.

Rev. Robert Walker skating on Duddingston Loch *page 37*

This charming study is understandably one of the most popular of the whole Scottish collection. It is very probably of the Rev. Walker (1755-1808) who was minister of the Canongate Kirk, but there are difficulties in accepting the family tradition that it was painted by Raeburn, whose style was quite unlike this.

Sir Patrick Inglis

This portrait was painted before 1790.

Sir John Sinclair of Ulbster, 1st Bart

This was probably painted in 1794-5 and is among the most celebrated of his earlier portraits. Sir John is wearing a uniform incorporating his own tartan, as Colonel of the Rothesay and Caithness Fencibles, which he raised in 1794.

Raeburn's Later Portraits

From the later 1790s Raeburn began to concentrate more on the portrayal of character. In most of his later portraits the background is dark, and the sitter is illuminated by a strong light from above. His people, most of all his men, are real people.

In aiming always at the general effect of the picture, Raeburn created as well, in such later works as *Mrs. Scott Moncrieff* and the *Glengarry,* a series of portraits whose style and subjects are so perfectly matched that they have become, like the portraits of Lawrence in England, inseparable from our image of the Regency.

Colonel Alastair Macdonell of Glengarry

This was probably painted in 1812, when it was exhibited in the Royal Academy. The Colonel was chief of the Macdonells of Glengarry, and is said to have been the model for Fergus MacIvor in Scott's *Waverley.*

Mrs Scott Moncrieff

This was painted about 1814. Raeburn's *Self-Portrait* was painted probably in 1815, when he was 59.

40. Orchardson: Master Baby

41. Paton: The Quarrel of Oberon and Titania

42. Ramsay: The Painter's Wife

Ramsay

Allan Ramsay (1713-1784) was born in Edinburgh. His father was Allan Ramsay the poet, author of 'The Gentle Shepherd'. He spent the years 1736-38 in Italy, and started a studio in London in 1739. After Kneller's death in 1723 the standard of portraiture there was not very high, and rarely rose above an undistinguished likeness fitted to a figure painted by the drapery man, in a pose based on an existing pattern. Ramsay very soon became one of the leading portrait painters in the city. Until the middle of the 1750s, when Reynolds was beginning, the only painter of comparable ability was Hogarth, whose serious excursions into the field of portraiture coincided with Ramsay's beginnings. Ramsay's success came from the vivacity and intimacy of his portraits. He maintained a studio in Edinburgh as well as the one in London, and the greater number of his commissions in both cities came from Scotsmen.

Sir Peter Halkett Wedderburn

It is dated 1746 and is one of the most successful portraits of Ramsay's early period. It contains the liveliness of characterisation which distinguished Ramsay from his predecessors and from most of his contemporaries. Aikman's *Self Portrait*, for example, is a sound portrait within the early 18th-century convention. But it seems to hold us at arm's length from the man himself, compared with the convincing presence of this 87-year-old man with the slightly ill-fitting wig.

The Painter's Wife *opposite 42*

Ramsay's first wife died in 1743. This is his second wife Margaret, daughter of Sir Alexander Lindsay, with whom he eloped in 1751. Ramsay's later portraits are distinct from those he painted in the 40s and early 50s for two reasons. By about 1754 Reynolds had emerged as a serious rival. Beside the masculine vigour of Reynolds' style, Ramsay's strength lay on the side of grace and delicacy, and he may perhaps consciously have exploited this essential difference between them. In 1755-57 Ramsay was in Italy, where he worked at the French Academy in Rome. It was natural enough that his style, which already had marked affinities with the work of the French, should be affected by this visit. This portrait was painted probably in 1759. The brisk clarity, with which the sitter had been set against the background in the earlier portraits, is replaced by a more subdued design, in which the relationships of colour are more subtle and more delicate.

Jean-Jacques Rousseau

Rousseau came to London in 1766 at the suggestion of David Hume, to escape persecution in France and Switzerland. This portrait, painted in 1766, was one of Ramsay's last paintings. He gave it to Hume, in whose house it hung beside the portrait of Hume himself (now in the Portrait Gallery). Rousseau was then 54, and is seen wearing his favourite Armenian costume. The head and shoulders are enveloped in a mysterious gloom strangely suggestive of the condition of Rousseau, whose persecution mania soon afterwards disrupted his friendship with Hume. The effect is unusual for Ramsay and was evidently deliberate, for it is already apparent from *The Painter's Wife* of 1759 that he had come to use the light as an element in the portrayal of character.

Runciman

John Runciman (1744-1768) was born in Edinburgh, the younger brother of Alexander. He accompanied his brother to Rome in 1766, and died in Naples. Very little of his work survives, since he died young and also he seems to have destroyed a number of his paintings in a fit of self-dissatisfaction. His known works are mainly small panels of New Testament scenes, four of which are in the collection. He had unusual imaginative powers, and his work is conceived in a romantic vein that was rare before the beginning of the 19th century.

King Lear

It is dated 1767. Lear stands with his hand on the Fool's shoulders, with Edgar, Kent and the gentleman behind. The picture was unique in its time for it has no connection with a stage performance. Runciman's source is Shakespeare's text, and he interprets the significance of the whole of the tempest scene, including its sea imagery, instead of representing a particular moment of it.

Scott

David Scott (1806-1849) studied at the Trustees' Academy. He painted imaginary scenes, drawn mainly from history or literature, which were inspired in part by the designs of William Blake (1757-1827) and contain echoes of Delacroix and the French Romantic movement which was beginning in the early 1820s. Scott's canvases, many of which remained unsold in his life-time, are often remarkable for their melancholy, even disquieting vision and for the crude forcefulness of their execution.

The Traitor's Gate

This picture was exhibited in 1842, when it was described as 'Thomas, Duke of Gloucester, having been secretly carried off from England at the command of King Richard the Second, taken into Calais, where he was murdered'.

Scott

William Bell Scott (1811-1890) a poet and painter, was son of an Edinburgh engraver and brother of the artist David Scott. He studied in Edinburgh and worked in London (1836-43), in Newcastle on Tyne (1843-58) and then in London and Ayrshire. He was a friend of the Pre-Raphaelites.

The Nativity

Finished in 1882, it is a portrait of a real barn near Penkill in Ayrshire where Scott was living. It was Rossetti's idea to make it the setting for Christ's birth. The details of the grasses and flowers in the foreground show Scott's knowledge of Pre-Raphaelite technique. Round the side of the distant hill the kings can be seen arriving like a procession in a fifteenth century Italian painting.

THOMSON

The Rev. John Thomson of Duddingston (1778-1840) was educated at Edinburgh University. While he was there, he is said to have attended the classes in landscape painting which were run by Alexander Nasmyth (see above). Like his contemporaries Turner and Constable, he must have learned most from the paintings of Claude.

Fast Castle from below

It was probably painted in the 1820s. Thomson's interpretation of the Scottish landscape and seaboard is romantic, an interpretation akin to the writings of Scott, who belonged to the same generation. Fast Castle, on the Berwickshire coast, provided the basis for a number of Thomson's compositions. One of these he painted as a gift for Scott, who had used Fast Castle as the model for 'Wolf's Crag' in 'The Bride of Lammermoor'.

WARRENDER

Thomas Warrender (active 1673-1713) was a Burgess Painter of Edinburgh whose recorded activities were otherwise mainly concerned with interior decoration, since there was then no precise line of demarcation between fine art and house-painting.

Still-Life *opposite 43*

This must have been painted in or after 1708, the date on the anti-Papist pamphlet. Also included are Warrender's guild membership tickets for Haddington (his birth place) and Edinburgh. An old inscription on the back hints at a secret, lost political meaning, possibly connected with the Union of Parliaments in 1707–"2 Royalist Allegorical Pictures/Explanation in the keeping of the family".

WILKIE

Sir David Wilkie (1785-1841) was born, a son of the manse, at Cults in Fife. He was a student of the Trustees' Academy in Edinburgh at the age of 14. In 1805 he settled in London, where he attended the Academy schools. His scenes of Scottish life, not quite like anything else being shown in London at the time, met with immediate success. He was elected R.A. in 1811. George IV, who is reported as saying that he could never have too many Wilkies in his collection, appointed him as his Painter-in-Ordinary on the death of Lawrence in 1830. He died at Gibraltar, on his return from a visit to Jerusalem.

Pitlessie Fair

This was Wilkie's first picture of importance. He painted it in 1804 while he was at Cults nearby, and most of the figures are, he says, portraits of the inhabitants of Pitlessie. But although he studied Dutch and Flemish paintings when he went to London, Wilkie did not know them at first hand at this stage. He had seen them in engraving, but he had studied more particularly the water-colour scenes of Scottish life by David Allan, who had recently died. Some years later Wilkie himself wrote of his picture, "Although it is no doubt very badly painted, it has more subject and more entertainment in it than any other three pictures I have since painted".

The Letter of Introduction

Dated 1813. It is a reminiscence of Wilkie's own experience when he first went to London.

Distraining for Rent

This was painted in 1815, and shows a ruined tenant farmer whose household possessions are being listed for sale to pay his debts. It is the only example of a tragic genre scene painted by Wilkie, and was to inspire the writer Jerrold with the idea for his stage play *The Rent Day* of 1832.

Wilkie spent the years 1825-28 abroad, mainly in Italy and Spain, and his study of the painters of the past and of contemporary work in France led him to a complete change of style. His pictures after 1827 are on a larger scale and broader in treatment, and their subjects are often drawn from further afield.

The Irish Whiskey Still *opposite 44*

Dated 1840. It was painted after a visit to Ireland in 1835, where Wilkie was impressed by the "Primeval simplicity" of the people of Connaught and Connemara, and wished to record their way of life before modern progress wiped out its picturesque aspects. We do not know whether he ever actually saw an illicit still at work.

THOMSON
WARRENDER
WILKIE

43. Warrender: Still-Life

44. Wilkie: The Irish Whiskey Still

47

PLAN OF THE GALLERY

1. Scottish
2. Prints and Drawings Gallery
3-5. Scottish
6. Information Room
7-13. European, to 1700
14. Study Collection
15. Temporary displays, new acquisitions, cleaned pictures, etc.
16. Dutch
17. 18th Century
18. English
19-23. French, from Poussin to Bonnard

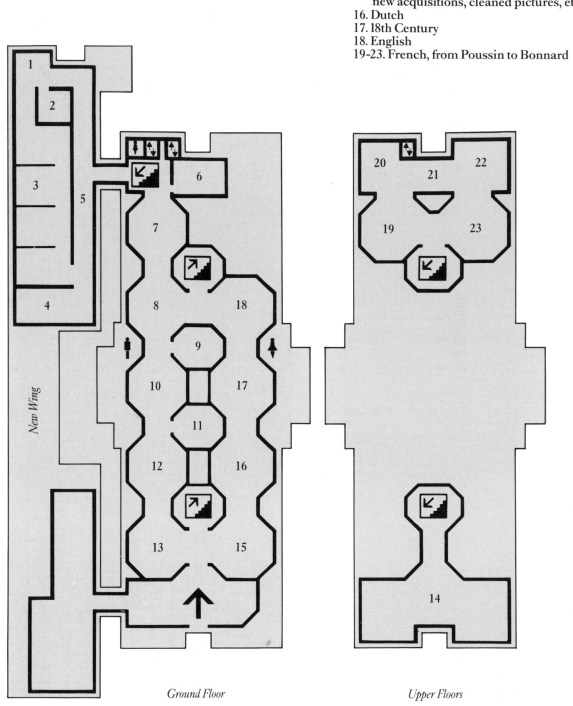

Ground Floor

Upper Floors